WORLDS

a Mission of Discovery

by ALEC GILLIS *foreword by* JAMES CAMERON

designstudio|PRESS

Art Direction: Scott Robertson
Graphic Design: fancygraphics
http://www.fancygraphics.net
Copy Editing: Anna Skinner

Published by Design Studio Press
8577 Higuera Street
Culver City, CA 90232
http://www.designstudiopress.com
E-mail: info@designstudiopress.com

Printed in China
First Edition, August 2005

ISBN 0-9726676-9-5

Library of Congress Control Number:
2005927188

Dedication

This book is dedicated to explorers and visionaries past, present and future, and to those who continue to light candles in the dark.

To Alaine, Camille, Devon, Grace and Isabella: my five points of light who keep me safely on earth.

CONTENTS

The renowned physicist Freeman Dyson once said "nature's imagination is so much richer than our own." In my explorations in the deep ocean, I've seen abundant proof of this, from swaying fields of six foot long red worms breathing sulfuric acid to blind shrimp swarming inches from jets of water hot enough to melt lead. As one of Hollywood's leading creature-effects designers, Alec Gillis understands this principle. An avid student of nature's creativity, he finds inspiration there for the fantastic beings he makes for the movies. Alec's respect for the ingenuity of nature pervades this book. In these pages you will see the richness of nature's imagination extolled through the fertility of human imagination, as he leads you on a journey to planets and biospheres of his own creation.

Worlds is more than just an absorbing and, ultimately, heart-wrenching work of fiction, it is a visual masterpiece. Not since Wayne Barlowe's *Expedition* has an artist conceived an alien biosphere in such baroque detail, while remaining true to nature's fundamental principles of adaptation, selection and ecological interdependence. These worlds are intricately conceived, their biomes scientifically plausible, while possessing a sufficient sense of the quirky and outrageous to mirror nature's own outlandish inventiveness.

Alec and I met in 1979 as amateur animators in Orange County, California, eager to share techniques and ideas. He taught me how to make molds and pour foam latex, and together we built an alien creature called the "Schmal" which we were intent on filming. Somehow all this fanboy activity led to getting our first jobs on a real movie together, on Roger Corman's cheap-o epic *Battle Beyond the Stars*. As I recall, Alec's sister was dating a carpenter whose brother worked on the model unit, and we parlayed that into an interview. The head of effects liked our models and the fact that we were young, eager and cheap, and so we passed through the looking glass into the world of Hollywood, albeit the low-rent fringe.

It was a gonzo time of 20 hour workdays when everything and anything seemed possible. We were excited just to be getting a paycheck for doing what we really loved. In the coming years Alec distinguished himself as a make-up and effects artist, and our careers diverged as I went into directing. Soon Alec partnered with Tom Woodruff, an alumnus of *The Terminator*, and the two formed their own company and rose steadily in status to rank among the foremost creature designers in Hollywood. Alec brings all his talent as a designer and storyteller to bear in this epic

and mesmerizing book. Among the ambitious goals he clearly set for himself, is creating a highly plausible interstellar mission. This is something Hollywood and most science fiction authors simply get wrong. The physics of traveling to another star system, even our closest neighbor Alpha Centauri, are incredibly daunting. The *Star Wars* and *Star Trek* mythologies with their massive battlestar-class starships zipping around galactic distances in days or hours, are so far beyond anything we might achieve in the next ten thousand years as to be meaningless to our real human experience of space exploration. This is not what star travel will be like. It requires enormous energy to accelerate even a tiny payload to near the speed of light, in order to cross these vast distances. If we ever do it, we will do it the way this book shows.

In *Worlds* you will see a much more plausible concept: a highly mass-constrained mission which sends one man, one lone explorer, out there to represent the human race. His ship uses an anti-matter drive and a long, tensile tether to isolate the manned module from the radiation the drive generates. This is very sound physics. A number of proposals for interstellar vehicles, including Dr. Charles Pellegrino's *Valkyrie* design, use these principles.

Most importantly, the physics of the mission set the stage for the drama... a lone explorer, giving up his safe life at home, giving up contact with his family and in fact all human companionship, to follow the most primal dream of the human race: exploration. This book captures the essence of exploration, especially the dedication and sacrifice of the true explorer.

Another ambitious goal of the book, beautifully executed, is to document the epic journey with images gathered by the explorer, using only the cameras at his disposal. The images adhere to a rigorous set of rules, feeling both photographically real while bearing witness to awe inspiring wonders.

Every image has a rationale. Early on, the drone camera provides the magnificent third person views, then later there are only the shaky handheld self-portraits and blurred images shot on the run through the jungle. This first person point of view is breathtakingly immediate. One can easily imagine the mounting concern at mission control as these images come in from the lone explorer whom they are powerless to help. When Earnest Shackleton was stranded for two years in the Antarctic, eating his dogs and surviving by the skin of his teeth, his team nevertheless always carried their bulky 8 by 10 camera. They knew that explo-

ration is a tree falling in the forest if the images are not preserved. The prime duty of the explorer is to bring back the tale, in both word and image... or at least to transmit those images somehow back to the billions of us who do not get to go. This is the ultimate mandate of NASA. As we venture forth into the infinite black night, it is the responsibility of the explorers, both robotic and human, to bring back those images which succor our souls, inspire our imaginations and answer our burning need to know the answers to the great questions.

This book looks and feels like exploration, the way it might really be. And it reminds us that the images which come back from the fringe of human experience are worth the sacrifice made by the explorers who take them. Even when some of those explorers make the ultimate sacrifice.

We haven't even solved all the riddles of our own planet, with centuries of science and thousands of explorers and investigators. The lone hero of this story, confronted with the pageant of life on new worlds, must bear witness to wonders and enigmas which will take centuries to explain. His struggle to observe responsibly, to record, and to understand... both for science and for his very survival, make a gripping narrative. We are left with a sense that the mysteries of this world are only glimpsed, and not fully unraveled. For every question answered, two more are asked. This is the very essence of science and the quest to understand the wonders around us.

As you take the journey in the pages that follow, you will walk in the shoes of the explorer. You will bear witness to the great mystery. The dream of exploration must be kept alive, and a book like *Worlds* can inspire that dream anew. Despite the dangers, I would not hesitate to sign up for an expedition to another star, if I could see even a fraction of the wonders seen in this book.

Alec Gillis proves that nature's imagination can inspire transcendent flights of human imagination... which inspire the rest of us, in turn, to get about the business of exploring what's out there, for real.

– James Cameron

Acknowledgements

As a Creature Effects artist, I'm fortunate to be surrounded by some of the most talented people in the movie business. Without them, this book would not have been possible. As the scope of this project expanded, so did their enthusiasm. Special thanks go to Steve Koch, for his unerring eye and mastery of "real" and virtual art; to the talented artist Chris Ayres for his unflagging support, and to Kevin McTurk for his beautiful camera work, complete commitment, and sense of humor. They are the backbone of *Worlds.*

I'm also indebted to my publisher, Scott Robertson and Design Studio Press. Being an accomplished film artist himself, Scott has created a paradigm that allows the artist to control every aspect of his work. As a novice in the literary world, I couldn't have asked for a more comfortable working relationship. Thanks to DSP for putting together a great team, including Tinti Dey, Anna Skinner, Jane Fitts, Marsha Stevenson and Neville Page.

My studio is a big place, but for several years every corner was cluttered with a miniature landscape, a half completed creature or a smoldering volcano. Tom Woodruff Jr., my partner in Amalgamated Dynamics, Inc., didn't just turn a blind eye, he gave support and encouragement at every phase. I thank him for this partnership, and for sharing the vision of creating a business where we build our dreams.

Lastly, I'd like to thank James Cameron for his influence and inspiration. We were both green when we met, but what I learned from him was not technique or tricks of the trade. Jim had an unconventional way of looking at things, a great respect for the craft of filmmaking and a sheer force of will that in some way still drives my efforts.

-Alec Gillis

The late afternoon sun was on the wane. The orange sky was aglow, soon the air itself would seem to ignite as light bounced off airborne dust particles, whipped into a frenzy by gathering winds. The desert valley was at its most beautiful. Lengthening shadows undulated along the jagged landscape, their movement giving the illusion of life to this barren place. Dr. Carlos Echevarria had no time for illusions. He had to complete this season's geologic survey before the weather turned too severe, and his window was closing quickly. His team was behind schedule due to a plague of mechanical problems that had rendered their vehicle unreliable. That morning he knew that they had almost no chance of completing the survey but still hadn't fully accepted it. The engineer's voice crackled over the radio, reporting that, at least for now, the motor was running. The setting sun told him they should be running too. With an efficiency designed to mask his disappointment, he called his team back to the transport.

It was its pragmatic design that earned the vehicle the nickname "The Box," and indeed, it wasn't much more than that on the inside. The only amenities were overhead racks for stowing gear and 10 seats for passengers. Everyone piled in, all aware that that their work was unfinished, and that they had run out of time. Sullen and quiet, the team spirit they had shared initially had become a kinship of failure. Dr. Echevarria considered making a short speech and scanned the vehicle to evaluate the team's mood. It was then he noticed the empty seat that should have contained one more team member. Vlasta Vovchanchyn, geologist and youngest member of the team, was missing.

The sun was now a pinpoint of light on the horizon, and the winds were increasing in intensity and decreasing in temperature by about 10 degrees every six minutes. Base camp was 50 kilometers of rough terrain away. A faulty vehicle and bitter cold made the distance seem even greater. Echevarria decided that he would not risk any team members in an ill-fated rescue attempt. If Vovchanchyn could not be reached by radio within 10 minutes, the Box would turn and leave without him.

Echevarria ordered the engineer to transmit via the vehicle's radio, since it was more powerful than his own portable radio. Fellow teammates crowded at the tiny windows looking for a sign of their missing comrade. The last of the sun's amber light had extinguished, only to be replaced by the cold, blue starlight of the clear desert sky. The engineer began pulling the vehicle around. The professional disappointment they all felt 10 minutes ago was replaced by something worse, something they always knew was a possibility but none had really prepared for. The risks of the job were well-known, as was the procedure in cases such as the one that faced them now. Most of them dealt with the risk by joking about it—now they had to deal with the procedure.

Hydrologist Marta Carslon-Woodard was a veteran of several geological surveys and had taken the inexperienced Vovchanchyn under her wing. Now she stared with tear-streaked eyes through a dusty rear window as the transport rumbled away. The floods cast a semicircle of light 10 yards behind the vehicle and illuminated the tire tracks left in the sand—twin snakes swallowed up by the darkness. She could see her own reflection in the window as well, and that bothered her. It made her feel guilty. It made her feel too much a part of it all.

She reached up and turned off the interior cabin light, and as her face disappeared from view, she noticed something else. Three points of light bobbed up and down in the blackness, just beyond the reach of the transport's floodlights. Was it a reflection from inside the vehicle? For a moment she looked around the cabin, expecting to see light glinting off someone's watch as they dusted off their shoulder or stuffed something into a duffle, but no one was moving. She looked back outside and saw the three points of light drawing away, losing ground. She shouted to Echevarria to stop and reverse the vehicle, and the cabin exploded with activity. The back windows crowded with faces peering into the darkness and chattering with excitement.

As the snakes uncoiled from the darkness, the glints of light reappeared, and then something else came into view. In the ridge of upturned dirt between the tire tracks stood Vovchanchyn. He was exhausted from chasing the lights of the Box for almost a kilometer and was doubled over, holding his gut. The vehicle eased toward him, and the doors were thrown open. Stinging cold wind cut through the cabin as the team dragged him in and administered first aid.

Echevarria couldn't help notice that for a man who was minutes away from dying of hypothermia, Vovchanchyn was downright giddy. A tear in his protective suit and a broken radio indicated that he had taken a fall and explained why he hadn't responded to any transmissions. The reason for his euphoria was something else altogether. He tightly clutched a slab of oxidized sedimentary rock, about the size of a serving platter. Its surface bore no unusual characteristics, and its rough texture made it look like any of the millions of rocks that were scattered throughout the valley. The prone Vovchanchyn proudly lifted it to Echevarria, who, in an effort to humor the delirious man, held it out to inspect it. As he studied the featureless rock, his eyes drifted past it to the faces of the team. One by one their expressions blanched as they looked at the opposite side of the slab. Echevarria slowly turned the stone over and stared at the pattern in the rock.

Whether it was the transport's dim light or Echevarria's own preconceptions melting away, after a few moments he was able to focus on the fossil embedded in the rock. It had a broad head, multiple legs, a long tail with a faint image of overlapping fins, and a row of vertebrae. He collapsed into his seat, delicately running his fingers over the imprint of the bones of a creature that lived millions of years ago. It was a find that would have gone unnoticed had it been discovered somewhere else, but it was found here, and it would change the course of history.

It had turned out to be a very good day on Mars after all. The transport chugged on through Valles Marineris towards MarsBase Three, carrying proof that the planet had once supported life. Not mere microbes, proteins, or "building blocks," but a fossil of a swimming, eating, reproducing vertebrate.

* * *

Soon Mars research would emphasize exopaleontology, the study of ancient alien life. By 2021, two years after Vovchanchyn's narrow brush with death, more than 300 fossil vertebrates had been exhumed from the red planet's rocky soil. Equatorial fossil beds were the most abundant, in places with names like Tharsis Rise, Candor Chasma, Gorgonum Chaos, and Coprates Chasma, which became meccas for waves of researchers sent by the four nations capable of sustained space travel. Back on Earth, the reaction to these discoveries was powerful and immediate. In the same way that the first dinosaur reconstructions captivated the Victorian era, the 21st-century zeitgeist was seized by all life-forms of Martian origin. Where the mighty beasts of Earth's past had roamed the landscape of children's imaginations, now the oceans of ancient Mars ebbed and flowed, and its denizens lurked the depths.

As recent as several million years ago the red planet had been blue, with most of its surface covered in water. A mysterious cataclysm caused Mars to lose its magnetic field, resulting in a rapid thinning of the protective atmosphere, exposing the surface to the sun's radiation. The water that did not dissipate into space submerged underground or collected at the poles in the form of dry ice. All life ceased in a single gasp of mass extinction, never to return. At the same time on Earth, near present-day Olduvai Gorge, a proto-human, whose fossil remains would later be named "Lucy," may have gazed skyward at the bright object that hung low in the evening sky and noticed that its familiar brilliant blue had faded. It would be hundreds of years before mineral oxidation gave Mars its red tinge. As exciting as these ancient scenarios were to the public imagination, they were still *ancient*. The world began to long for proof of alien life that still existed. With renewed vigor bolstered by tremendous public and political support, scientists began to ask the question: "*If life existed on Mars millions of years ago, could it exist on another planet now?*"

This was the genesis of the Worlds Mission.

The Challenge

It was an effort that took 50 years and required the contributions of 26 nations. The resources required were greater than any single nation could bear, which demanded a greater degree of international cooperation than had ever been attempted. The process could have been a simpler one if not for one critical element: human nature. The competitive spirit that had driven countries to the forefront of technology was the same spirit that at times threatened the mission's success.

The United States was the most experienced in the terrestrial exploration of other planets. They had explored about 10 percent of Venus' surface using robots and had established multiple manned bases on Mars. Initially, NASA had assumed that it would be in charge of the Worlds Mission, and all other space organizations would fall under its control. Russia had a slightly different opinion and voiced it loud and clear. They had more experience in prolonged space flight as well as in building space stations in zero-gravity. China had less experience in space travel but had more satellite launches than anyone. Japan's emphasis on alternate fuel transportation had established them as leaders in proton/-antiproton theory. France was a leader in the newly developing area of Accelerated Pulse communication, which would eventually lead to faster-than-light sound and image transmissions. Germany and the United Kingdom had already teamed up and virtually cornered the market on high-end digital imaging cameras, like the ones used by NASA's *Oracle* probes during the mapping of Venus. Clearly a new governing body was needed to administrate over the Worlds Mission, and it had to be internationally balanced.

It was agreed that one member from each of the 26 contributing nations would be included in the new World Space Organization. Unlike the United Nations, there were to be no votes cast or counted. Proposals on method would be submitted to committees comprised of experts, who were free to research the approaches in order to draw informed conclusions. When all committee members were ready, they would withdraw into a closed-door session and hash out a compromise of approach.

Early on, governmental pressure was exerted on individual scientists in an attempt to sway committee members toward results that were deemed politically advantageous. In a revolutionary move, the 26 scientists drew up a charter that declared the organization outside the political process and, therefore, immune to political pressure. This "Declaration of Scientific Independence" was first presented to the media, which carried the story around the globe, garnering tremendous grass roots support for the rebellious scientists. It was then presented to the respective world governments. The declaration was ratified, and the World Space Organization became an apolitical body. It was this bold move that allowed the Worlds Mission to proceed relatively unencumbered by the politics of the day. Of course, the WSO was only as apolitical as the world's governments would allow since they were financing the mission. With public watchdog groups monitoring government involvement, however, a system of checks and balances evolved and the WSO was able to stay on task.

The mission's five-decade history was not without turbulence. In the beginning, some optimistically believed that this new cooperation between nations was the dawning of a new era of enlightenment. If the world could band together in the name of science, surely it could do the same to end world starvation, disease, oppression, and war. Though Worlds represented man's highest aspirations, it did little to change his fundamental nature. Wars still erupted over border disputes, religious intolerance, and ethnic differences. Conflicts between WSO member nations resulted in 10 years of nonparticipation for Pakistan and India, three years lost between China and Unified Korea, and five years of diminished participation by France due to the economic drain caused by its military quagmire in Morocco.

The WSO also found itself the target of religious extremism. On Christmas Eve 2034, a homemade neutron bomb exploded at a test facility outside Salt Lake City, Utah. The timing of the attack was significant to the Christian fundamentalist group that claimed responsibility. Fortunately, most of the staff was home for the holidays.

Islamic fundamentalism also made a brief resurgence with scattered bombings targeting key individuals in the Worlds mission. Fundamental extremists considered those involved in the effort to locate extraterrestrial life to be either infidels or sinners, depending on which prophet they followed. The fear that mankind's unique place in the universe would be compromised by the discovery of life on other planets was indeed terrifying to some. Fortunately, most people of faith considered the existence of extraterrestrial life as further proof of a Divine intelligence. The less spiritual found comfort in the idea that we were not alone.

There were myriad technological challenges as well. The science of locating possible life-supporting planets had always taken a back seat to more practical concerns. Mars' untapped abundance of minerals was one key to sparing Earth's dwindling resources and overtaxed ecosystem. The MarsBase program was an important first step in preparing the planet for mining. Asteroid mining was also enjoying some limited success. The thrust of these efforts had resulted in technology that would surely be of use once life was found, but it was the finding that presented the first problem.

Spectroscopic telescopes had long been used to identify planets orbiting distant stars. Late-20th-century astronomers discovered that the Doppler effect revealed the pull of light that an orbiting planet has on its parent star, thus showing the presence of that planet without actually seeing the planet itself. Most stars are about 10-billion-times brighter than a planet, requiring the use of infrared telescopes to reduce their glare, and the planets themselves, rather than merely their effect on their sun, became visible.

But finding a planet and *finding life* on that planet are two very different things. The Interferometric Probe was developed for this purpose and referred to the optics system that nullified solar interference so that a planet's spectral signature could be studied. The delicate instruments packed aboard the probe were carried beyond the orbit of Jupiter, a safe distance from the massive, infrared-obscuring dust cloud that extends past Mars. From its unobstructed vantage point, the probe could peer deep into space and look for life's telltale signs: ozone, which would indicate an Earth-like atmosphere; oxygen, which if created by plant life would indicate photosynthesis; methane and carbon dioxide, which might be produced by the respiration of animal life. For pragmatic considerations, the search was limited to those systems within a 10-light-year radius of Earth, whose star was an "M" class sun like our own. Earth-sized planets that were a comparable distance from their sun were considered to be more likely to hold life. If these conditions were met, many wondered whether alien life-forms would really be that different from those on Earth.

The Man

Like many 15-year-olds, Jeff wasn't entirely happy with his life. It wasn't a terrible life, but he felt a low-grade dissatisfaction with it just the same. Everybody complained about their parents, but Jeff's were different. They seemed to be holding him back. He knew he was a gifted athlete; his times in the 50-yard dash were always a full second less than the fastest kid in the school. In his freshman year, he bench-pressed more weight in PE than the Varsity noseguard and got pushed around by the starting linemen. So he quit weightlifting. When told about the incident, his father's response was, "Probably just as well. Football's too rough a sport." Jeff hadn't even expressed an interest in football, yet his dad seemed eager to quell any thought of it.

It wasn't as if they weren't from a sports family. His mother had gone to college on a rowing scholarship, and his father had been a minor league baseball player, yet they seemed determined to keep Jeff out of athletic competition. Come to think of it, it wasn't just his parents. The school coaches seemed thoroughly impressed with his abilities on the one hand, and on the other, totally uninterested in having him on any team. The only time he broached the subject was after wrestling tryouts, when he mustered his courage and marched into Head Coach O'Hara's office and practically demanded to be allowed on the team. The coach smiled at

stiffly while Jeff implored him, and then patted him on the back and said, "Sports aren't for everyone, Son." Before Jeff knew it he found himself ushered out of the office and walking past the 10 wrestlers he had just pinned in tryouts. He heard a muffled sound, but didn't know it was Coach O'Hara's fist going through the wall in frustration.

Some weeks later, Jeff's dad appeared at his bedroom door with a printout of his plummeting GPA and said, "Come with me." In the living room were his mother, their family pediatrician, and a representative of the Worlds Mission. In a whirlwind of details, Jeff's image of his life slowly turned over, like a familiar painting that concealed another behind it. The subject was the same, but the brushstrokes were more bold, the details more crisp. Jeff, along with 22 others teenagers from around the world, had been chosen as a possible candidate for the first manned mission outside the solar system.

Vague memories of "play days" came back to him. White walls, colored blocks, games, math problems, obstacle courses, and lots of grown-ups with notebooks: These were Jeff's first childhood impressions of the Worlds Mission. He also remembered not getting along with the other kids. They were mean and the adults didn't seem to do anything about it. Instead of stopping a quarrel over a toy, they would furiously scribble, making notations about each subject's behavior and character. Jeff's pediatrician, Dr. Calig, as it turned out, was also on the Worlds payroll. He was charged with the medical care of the seven American children chosen for the project. They lived in five different states and all three time zones, which explained why the good doctor had always seemed so tired. His job was not merely to maintain the healthy bodies of the Worlds children, but to *enhance* them as well.

Doctor's visits often involve shots, but Jeff wasn't aware that he was getting more than most kid. Nor was he aware that the overnight trips to the hospital to have his appendix dissolved were actually opportunities to administer gene-manipulating nanotechnology into his system. These tiny medical robots performed a variety of gene-manipulation functions, such as altering the thickness of the cell walls in preparation for cryogenic biosuspension, increasing bone and muscle density to counter their loss in weightlessness, and illness prevention. Jeff went to the doctor many times but never for a cold. Worlds kids didn't get colds.

The agreement between WSO and the parents of selected children was that the youngsters remain uninformed of the project until they turned 18. Their peers' reactions or media attention might affect them adversely, especially if they knew that they were in a secret competition with 21 formidable opponents from around the globe. Upon turning 18 they were to be fully informed of the program and allowed to choose whether to continue.

From that point on, the time commitment for the candidate was huge, as was the financial commitment for the WSO. It was definitely in everyone's interest to be absolutely certain that each individual made the right decision. If years of study in exobiology, geology, astronomy, physics, chemistry, and all related fields sounded interesting, what about the years of grueling physical preparation as well? For this reason candidates were kept apart from their parents for two days to make up their own minds.

Those who decided to leave the program were encouraged to continue living their lives normally, despite their genetically enhanced bodies and reputations for being the academic cream of the crop. Many of those who declined further involvement were snatched up by top universities. One individual committed suicide by reprogramming her nanobots to literally deconstruct her body from the inside out. (The family's lawsuit against the WSO was eventually dismissed on the basis that there was evidence of depression prior to the subject's genetic enhancement.) The other Worlds kids went on to lead productive lives in many fields of endeavor, except one: They were barred from professional sports.

At last his parents' dismissive attitude toward sports made sense to Jeff. They had not been trying to hold him back from athletics; they had been strictly forbidden to allow their genetically advantaged son to participate in them. Performance-enhancing drugs had long been legalized, but it was illegal for professional athletes to enhance their bodies through nanotechnology. The same was true for amateur athletes, even though the technique was not available on a wide scale to the public. Jeff's parents had secretly endured their son's frustration as he was kept out of competitive sports. They also endured Coach O'Hara's desperate lobbying to allow him to play. After the coach was informed of Jeff's status in the program, he stopped lobbying and started punching walls in frustration.

By the day of his high school graduation, Jefferson Walker Brooks had carried his secret with him for three years. He was known to his friends as a kid who had the grades and athleticism but lacked drive. While his buddies established their place in the high school hierarchy, Jeff's eyes would drift heavenward from the brightly lit rectangular gridiron to the night stars above. Each shimmering sun represented a possible future, a beckoning destiny he couldn't ignore. Most of his classmates thought he was just a daydreamer, but on one occasion he tried to open up to a friend who would later be quoted in an interview: "Once, out of left field, he told me he was part of a secret program to send a human to outer space to contact alien life-forms. It was really creepy, because I saw a dead earnestness in his eyes. Then he broke out laughing and said it was a joke, but I never forgot that look. I just thought he was weird. How was I to know?"

The Machine in the Man

The robot floated through a strange and alien environment—a high-tech visitor in a less than welcoming world. Upon sighting its target life-form, it attached itself to it and injected its prey, killing it instantly. It would repeat this action several hundred times until its energy source was depleted and then fall away, useless. The alien "world" was inside Jefferson Brook's bloodstream; the life-form was an influenza virus and the robot a microscopic piece of nanotechnology. The hundreds of thousands of tiny nanobots introduced into his system were in a constant quest to fight off infection and illness. Many were at work in a subtler but more profound way. They had attached themselves to his DNA strands and were busy restructuring them.

It had long been known that the most successful endurance athletes were those whose bloodstream transported oxygen to the muscles most efficiently. Conversely, the buildup of lactic acid in the muscles, that which causes the "burn" of muscle fatigue, was virtually nonexistent in these athletes. Transporting lactic acid out of the muscle was every bit as important as transporting oxygen in. The rigors of life in space, along with the potentially strenuous activity of terrestrial exploration, required Brooks to have a top athlete's endurance. Not having been fortunate enough to be born with this trait, the nanobots were programmed to make that necessary genetic modification, among others.

Cryogenics had always been one of the Holy Grails of long-term space travel. The freezing and unfreezing of tissue had been attempted since the late 20th century with unsatisfactory results. Terminally ill and excessively wealthy, some people had engaged less than reputable cryogenics firms of the era to freeze their dying bodies to be thawed sometime in the future when the cure for their affliction was discovered. By the time cures were discovered, many of the firms had gone bankrupt or simply disappeared, pulling the plug on the business and leaving cryogenic chambers to become nothing more than stainless-steel coffins. In several instances, greedy descendants of those frozen intentionally damaged chambers for personal gain. A frozen person was a living person, according to the courts, and inheritances were only doled out after death.

The real problem with cryogenics was at a cellular level. Human cells are mostly water, and they react to cold and heat the way water does. Freezing the cell solidifies it while contracting it. Rapid freezing minimizes the effect but does not eliminate it. Thawing, which cannot be accomplished quickly, causes the cell to soften and expand. The result of this push-pull is a breakdown of the cell walls, which effectively destroys them. The favored technique of the late 20th century was the use of liquid nitrogen, which tended to cause what most bachelors call "freezer burn," like a neglected steak left too long in the back corner of the freezer.

The solution to the problem was two-fold: first, genetic modification of the cells to thicken their walls; second, the introduction of frog DNA. Certain frogs had been observed to go into hibernation when triggered by environmental causes. The lack of water caused some to burrow into the mud, only to emerge two years later when the rains returned. Others froze solidly with the sudden onset of winter and thawed in spring, unfazed by the ordeal.

Frog DNA interwoven with Brooks' own would be commanded by his internal nanotechnology to activate the hibernation process. As his heart and respiration slowed, the suspension chamber temperature would drop to slow them further. In effect, a complete metabolic standstill could be achieved without the severe cell-damaging freezing of past efforts. Since the process only relied partly on freezing, it was referred to as bio-suspension rather than cryogenics. (The subject of frog DNA was world-wide fodder for humor aimed at the Worlds Mission. *The New Yorker* ran a cartoon showing a space-suited Brooks sitting on a lily pad, with a caption that read: "One great leap for mankind.")

The degree to which Brooks would be integrated into his ship (and his ship integrated into him) was unprecedented. In the past, medical monitoring equipment had been a component of the ship-board technology. In order to assess the health status of a crew-member, he or she had to get to the medical station and "hook up" to it. In the case of the Worlds Mission, health-monitoring technology would be imbedded in Brooks' body in the form of nano-medibots, which would constantly evaluate the biostatus of every aspect of his health. Information relayed to the ship's medical computer would then be diagnosed, and instructions remotely transmitted back to Brooks' medibots, which could then internally administer drugs, effect tissue repair, or fight infection. Even in the most Earth-like of atmospheres, protection from microbial life-forms was critical. In the same way that Native Americans were susceptible to European diseases, so Brooks would be at a disadvantage without his microscopic army of robot doctors.

To Sleep

She had never liked the dark. The nightlight on her dresser was supposed to give her comfort at bedtime. Tonight, however, it had the opposite effect. Her mother had tidied up and rearranged the things the girl had

and moved the music box to the far end of the dresser, away from the nightlight. The china ballerina was a friend again, and as she carefully wound the key on the box the dancer began her pirouettes to the halting notes of "Beautiful Dreamer." Now back to bed. The girl crouched to the floor, like a sprinter in the starting blocks, legs like coiled springs. It was her ritual, to see if she could get into bed before the room fell dark. She never did, of course, but some part of her always hoped that this time would be different.

"Lights!" she shouted, as she leapt into the air. Even though she had given herself a head start, she felt the room go dark before both her feet left the ground. She hit the mattress and pulled the covers over her head. *The speed of light,* she thought. *That's what it would take. That's how fast Dad will go.*

* * *

"What are they gonna do with all my stuff?" Margaret asked her mother. "It will all be packed up so it's there for you when we wake up," her mother replied.

Margaret could tell her mom was a little tired of answering the same question again, but for some reason she felt compelled to ask it. There was a comfort in knowing the plan hadn't changed, especially a plan as big as this.

"And how old will Daddy be when we wake up?"

Her mom answered in a monotone as she stared out the car window at the gray landscape. "About two years older than he is now, but we'll be asleep for about 12 years."

She'd been told that if she didn't go to sleep she'd be 20 when her dad came back. *Twelve years without Daddy.* The last two years had been hard on her. She had seen less and less of him as his training was stepped up in preparation for the trip, and the thought of 12 years without him was unimaginable to her.

"Will I remember him when we wake up?" she asked with a tinge of panic in her voice. Here was a question that she had never asked, and it was a good one. No one had ever been in biosuspension for 12 years, and her mother honestly didn't know the answer. The process had been explained, the risks assessed, but she'd never thought of asking if memory might be affected. She took her daughter's hand and gave it a reas-

were a couple of day beds and some overstuffed chairs, a kid's craft table, lots of books, and of course a wall-sized, thought-activated computer screen. The technicians encouraged her to play with everything, but she found herself just walking around the room looking at the objects like a guest in a museum. Even though the place looked homey, it clearly had not been lived in. She could picture a team of designers presenting their sketches of the perfect family room to a bunch of other people who had no idea what an eight-year-old kid wants the most. Worlds people were like that. Always smiling, always trying hard, and always taking her Dad away. Right now, she just wanted them to leave. When her mom entered she asked, "When will Daddy be here?" Almost as soon as the words came out of her mouth, he came around the corner grinning that broad, gap-toothed smile she missed so much. Lately she saw that smile less and less. But now everything was the way it should be: the three of them like a regular family, not a Worlds family—at least for a while. They would spend the day together, but tonight when they went to sleep it would be for a very long time.

Margaret felt herself getting sleepy in the afternoon and had tried to resist it. She knew that the shiny-black hemisphere on the ceiling had something to do with it. It was the one thing in the room that really didn't belong. The sun had faded now, and she could no longer fight her fatigue. Her metabolism was slowing and preparing her for biosuspension. She imagined tiny frogs in pajamas floating down a lazy stream. Looking up from her father's lap, she noticed his eyes were red and watery. He must be yawning too, she thought. She reached up and touched his warm neck, like she always did at bedtime. "I wish I could go with you, Daddy."

A tear spilled out of her father's eye, and by the time it landed on her cheek she was fast asleep.

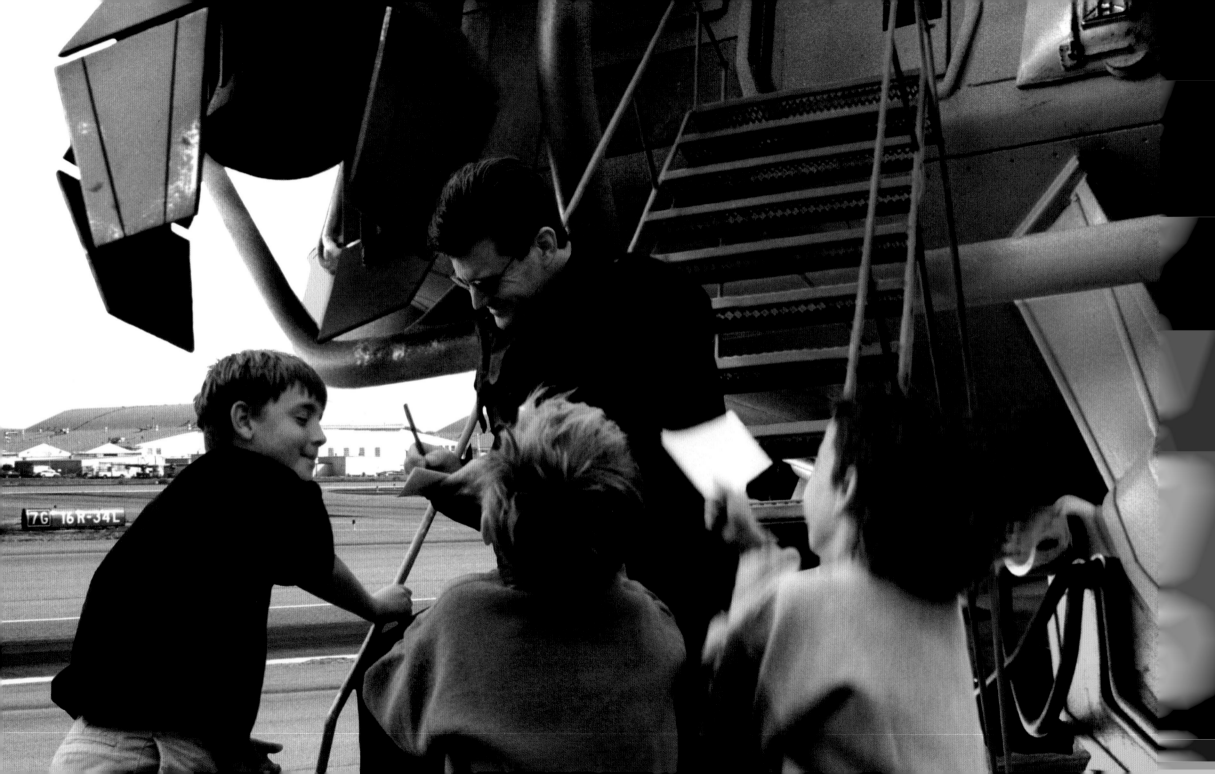

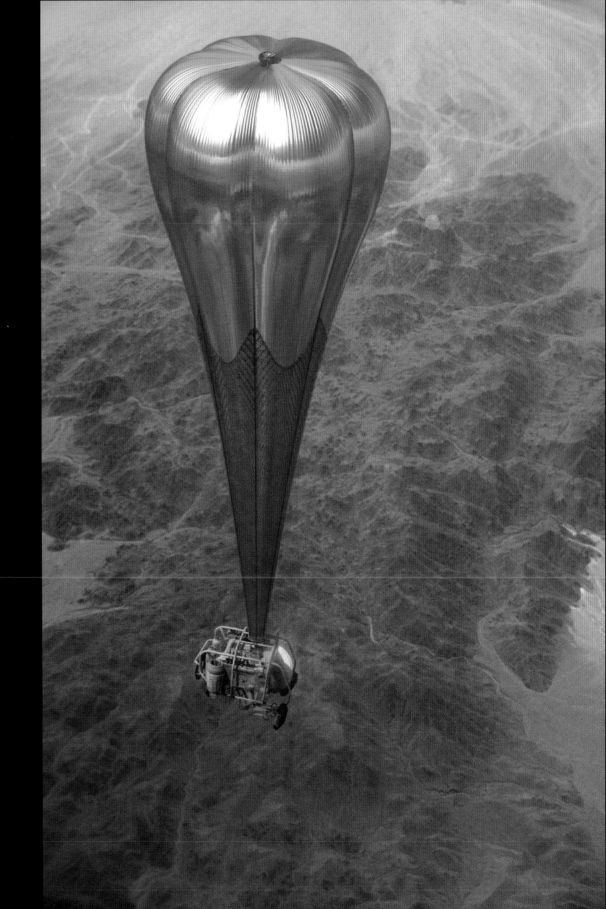

The new age of exploration begins
on a cool February morning in 2071
with the bioresearch craft *Lowell's* test flight over the Nevada desert.

The ship is named for the 19th-century astronomer Percival Lowell, who optimistically claimed he had discovered life on Mars. The more cautious Russian pioneer in the search for alien life, Nikolai Kardashev, provides the name for the interstellar tug that tows the craft to the Proxima Centauri system. There the *Lowell* enters the atmosphere of a life-supporting planet and deploy its fuel-conserving Mylar support balloon. Directional thrusters steer the craft, and upon departure the balloon is jettisoned from a high altitude, at which point the main boosters will provide the thrust for the *Lowell* rendezvous with the orbiting tug. Brooks compares piloting the unwieldy craft to "rowing with tennis rackets."

The eye in the sky, otherwise known as ROC 2
(Remote Operated Camera), is test flown at Bainbridge Labs. The company, based in Palo Alto, California, was one of many private firms contracted to develop new technology for the Worlds mission.

Although tested here in tethered mode, ROC 1 and 2 were designed to operate independently in different environments, ranging from liquid to the vacuum of space. Bainbridge is known for their breakthroughs in Personal Assistant Robots, specifically for the sight deprived. The ROCs possess the next generation of the same virtual imaging technology that has brought sight to those unresponsive to ocular nanosurgery. The cross-shaped aperture reveals a 3-inch-thick quartz lens, which houses 50 digital sensors capable of 180-degrees-horizontal and 120-degrees-vertical environment scans. A sophisticated AI "brain" linked to the digital optics controls flight and makes environment scans for Brooks should he choose not to operate the craft himself.

Ion Field Generator

Matter/Anti-Matter Drive Pods

Tow Umbilical

Communications and Sensor Array

Liquid Hydrogen/Liquid Oxygen Fuel Tanks

Radiation Shielding

Research Vessel "Lowell"

Positive/Negative Induction Ring

Collapsible Spars

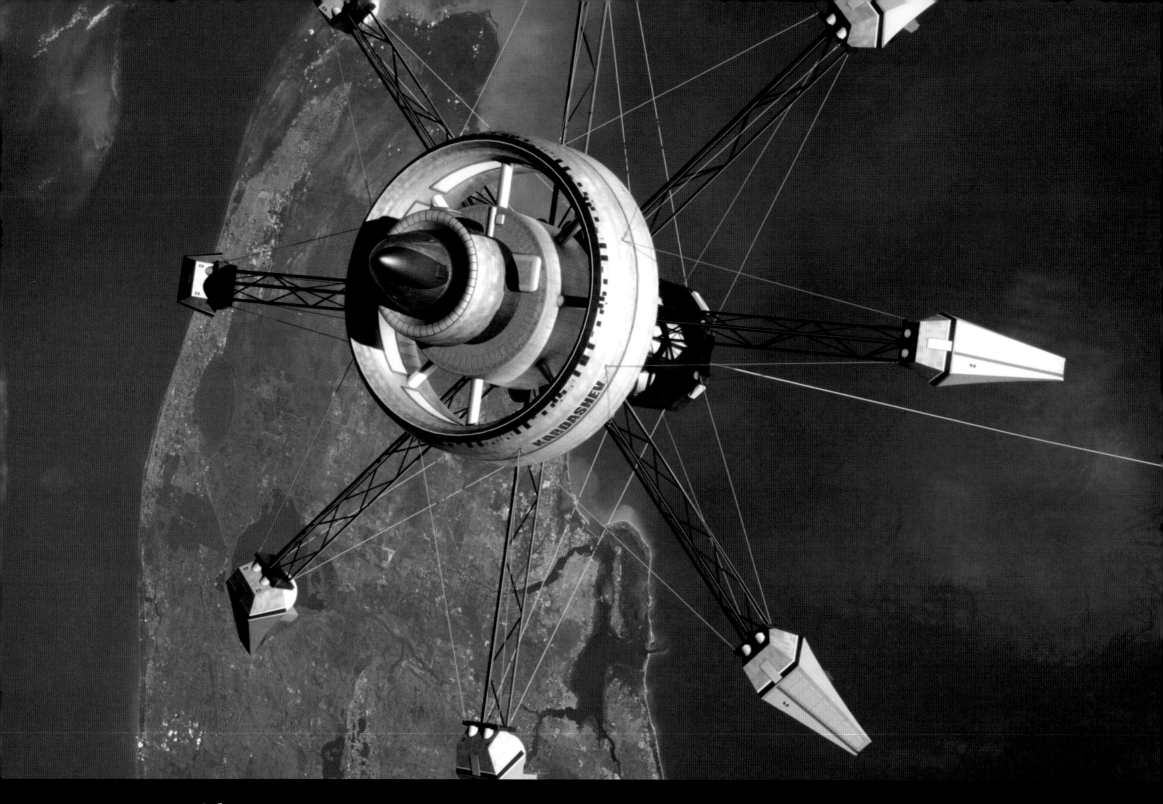

Dangling like a **spider,**
the interstellar tug, *Kardashev,*
hangs over southern Florida
awaiting zero hour.

The 26-nation Worlds team assembled the vehicle in space.
Building and launching from weightlessness requires less
energy and eases structural design requirements. The tug
is essentially all engine, with no living quarters included.

Brooks' home for the five-and-a-half-year journey is
aboard the research vessel, *Lowell,* towed far behind the
Kardashev's power source.

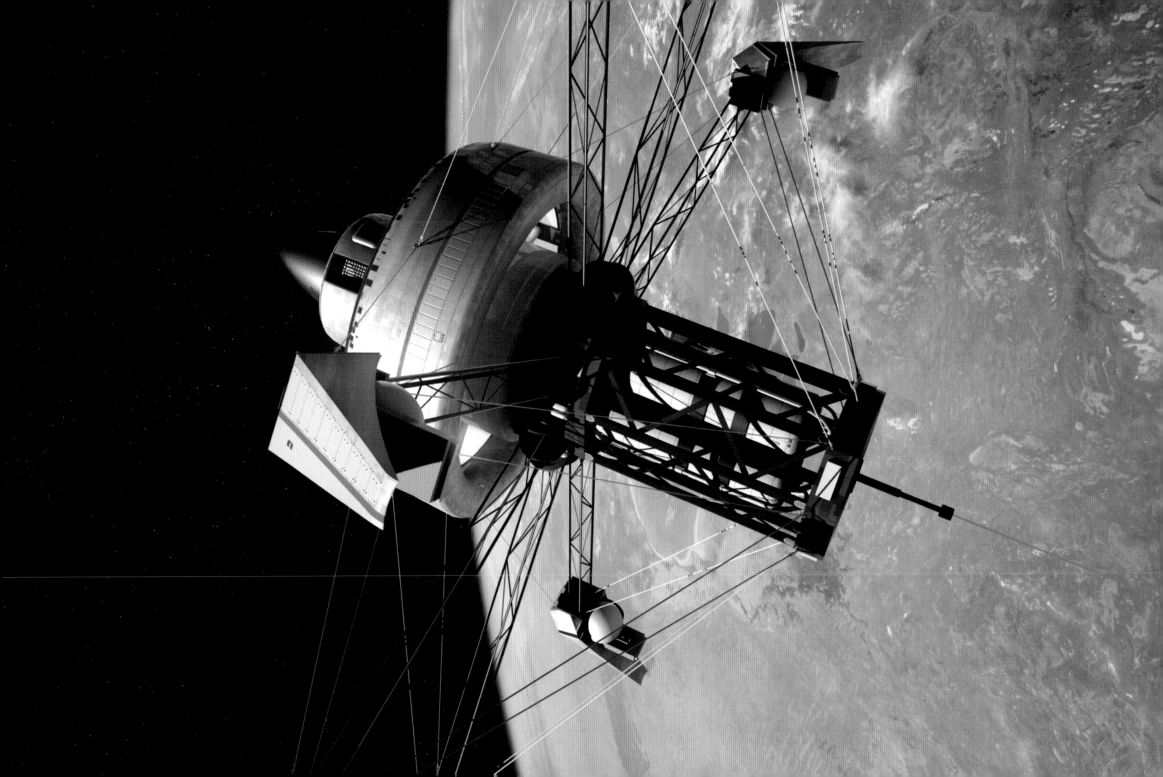

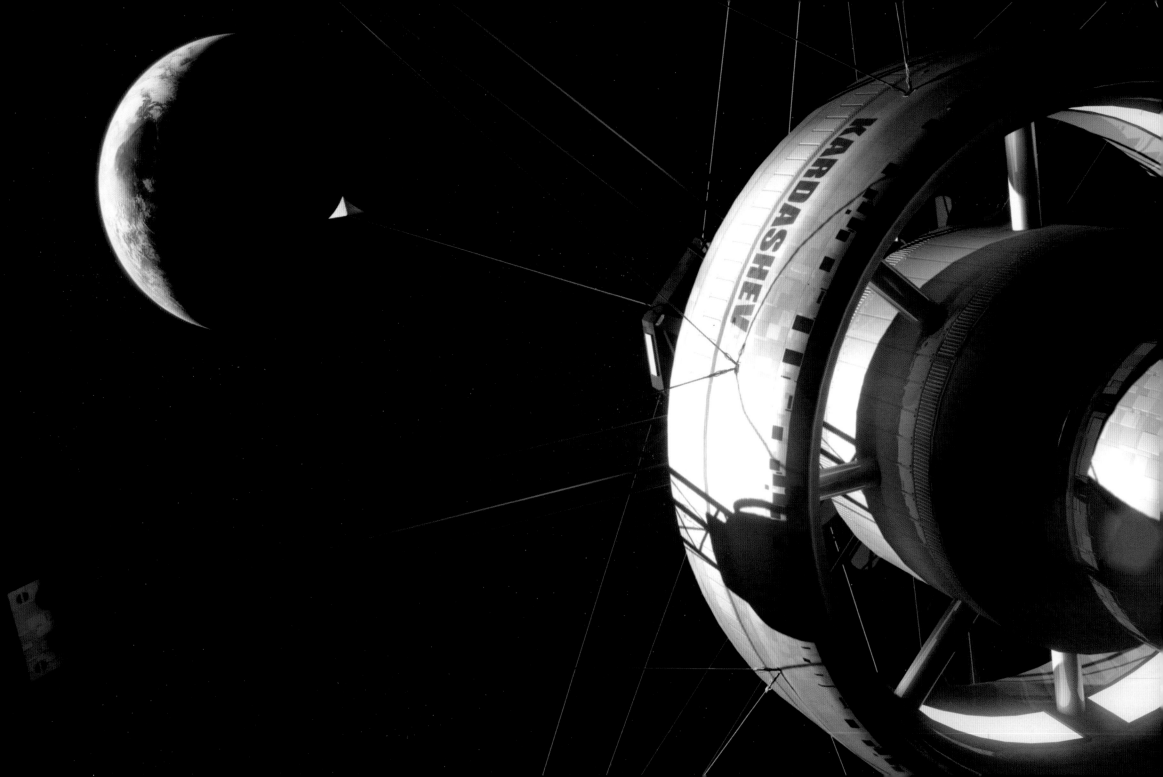

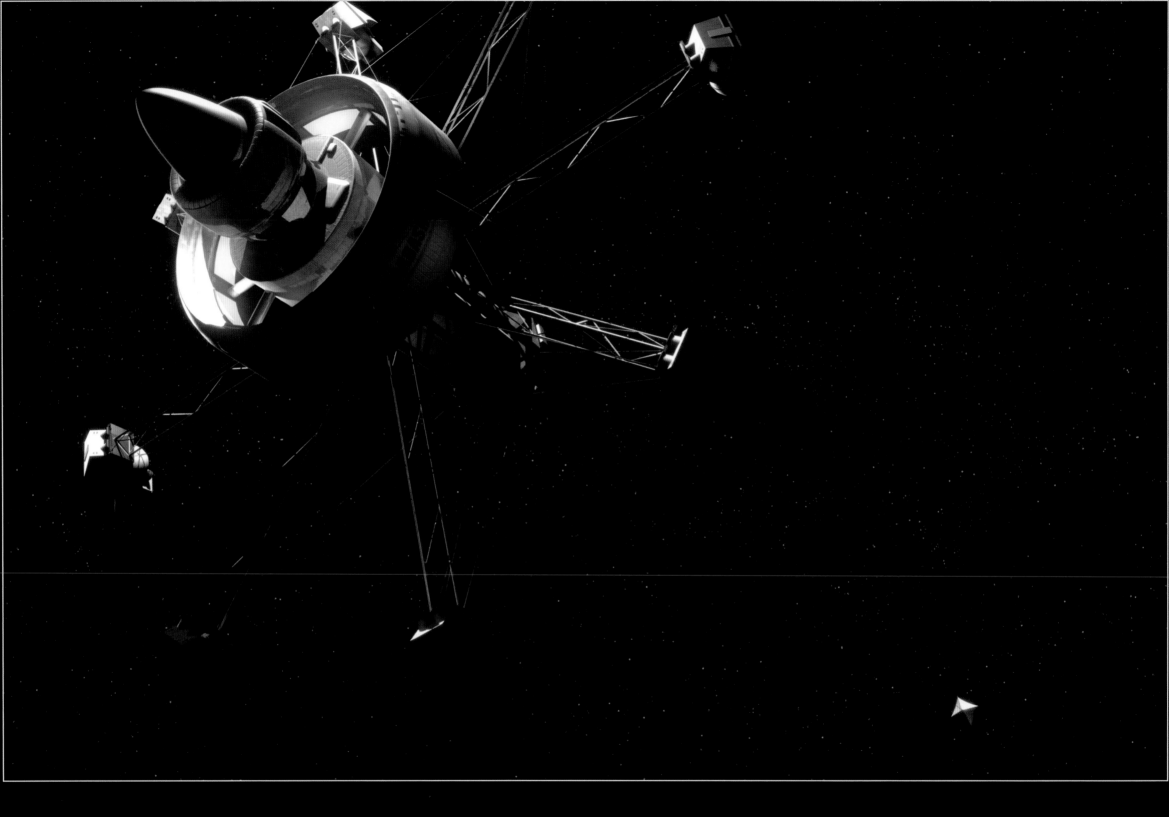

The crowded void of space presents a constant threat to the ship.

When traveling at near light speed, collision with the tiniest particle (of which there are billions) can cause catastrophic damage to the vessel. The solution is the protective ion field generator in the nose of the *Kardashev*, which acts like an invisible cowcatcher.

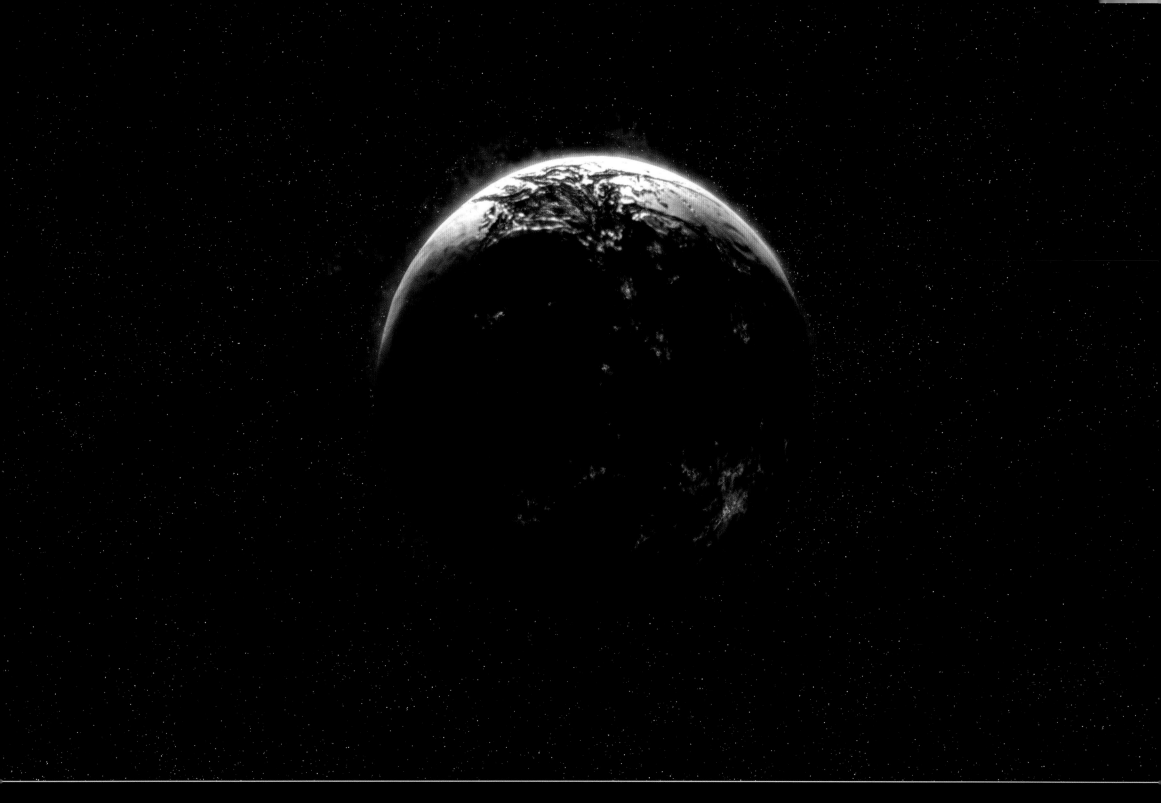

Killer of planets, devourer of worlds; this silent assassin behaves much like a bacterium, consuming the metals and minerals of its host. The *Lowell* detects life signals emanating from Proxima

Centauri's 11th planet, or so Brooks assumes.

"When I found no evidence of life there, I began to return to the tug, fearing a major failure of instrumentation. As I circled the dark side of one of the planet's many small moons, I discovered spectacular proof of life on an alien world. It was

This is the largest life-form (roughly the size of California) discovered by the Worlds mission, and analysis of biothermal activity and sonar mapping shows the afflicted area is about 300 years old.

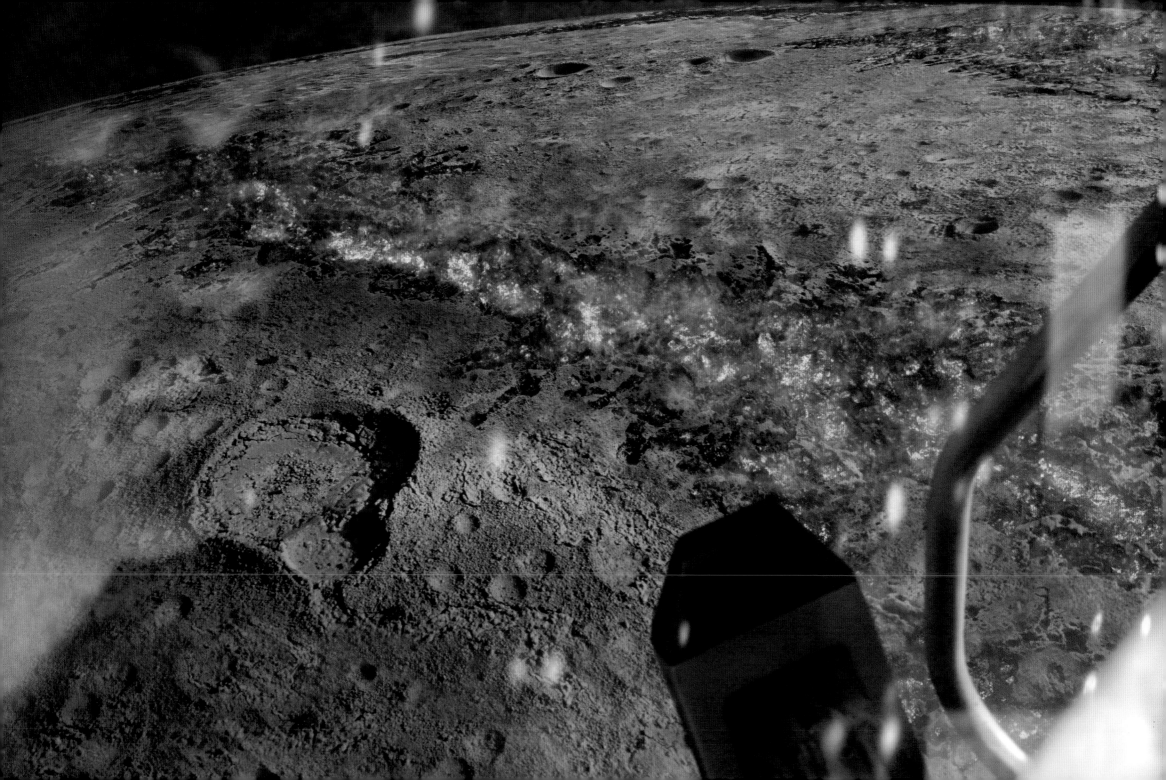

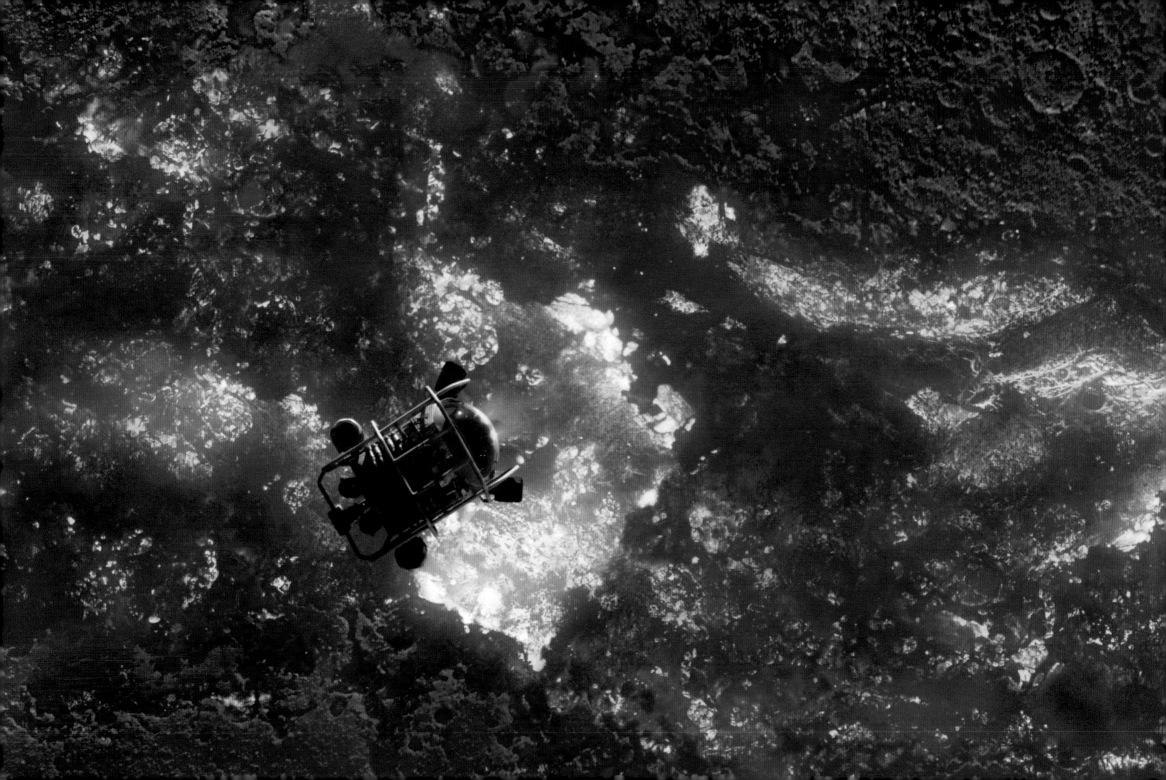

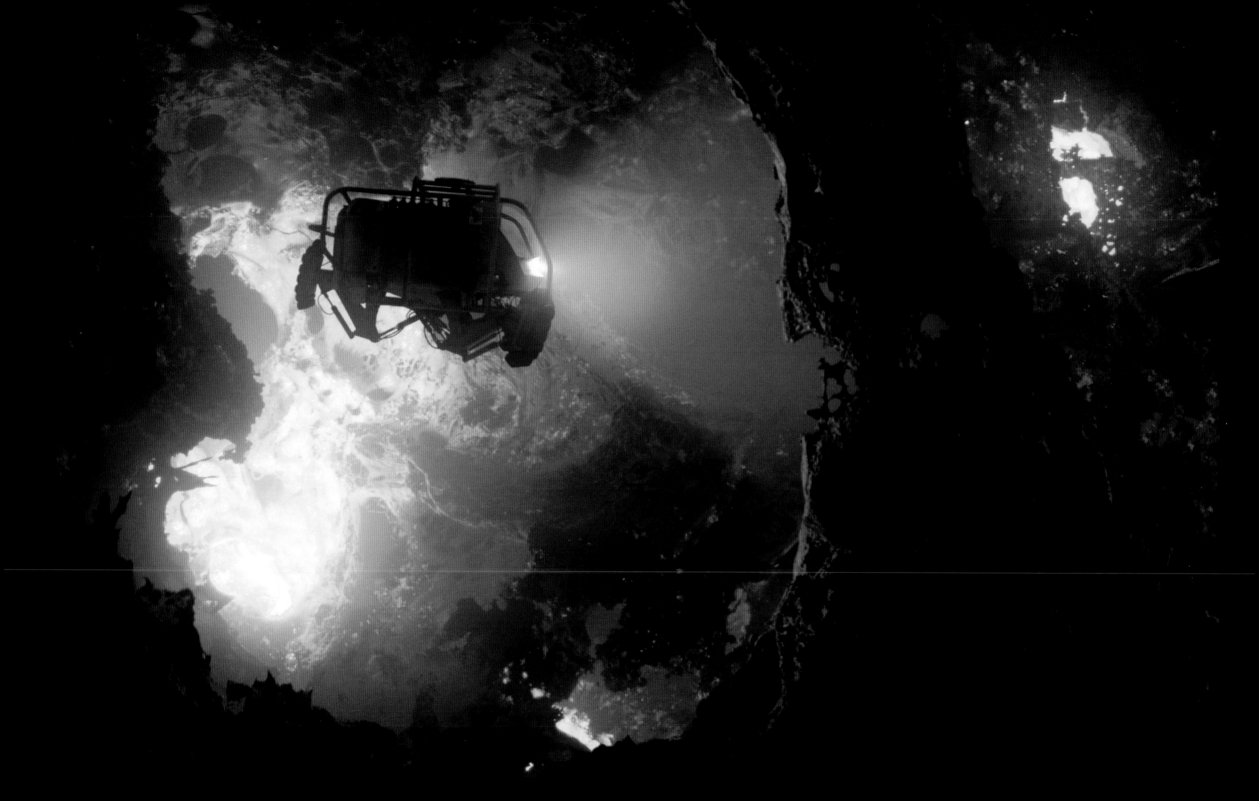

The cancerous remains
of a **virulent world**
in the form of delicate columns
reach heavenward

The low gravity of the moon only delays their inevitable demise. It is estimated that if this organism reached Earth, life as we know it would be extinct within 100 years.

kill more rapidly than the actual consumption of the planet. In another 1,000 years, Earth would break apart, sending pieces careening in all directions, making victims of our

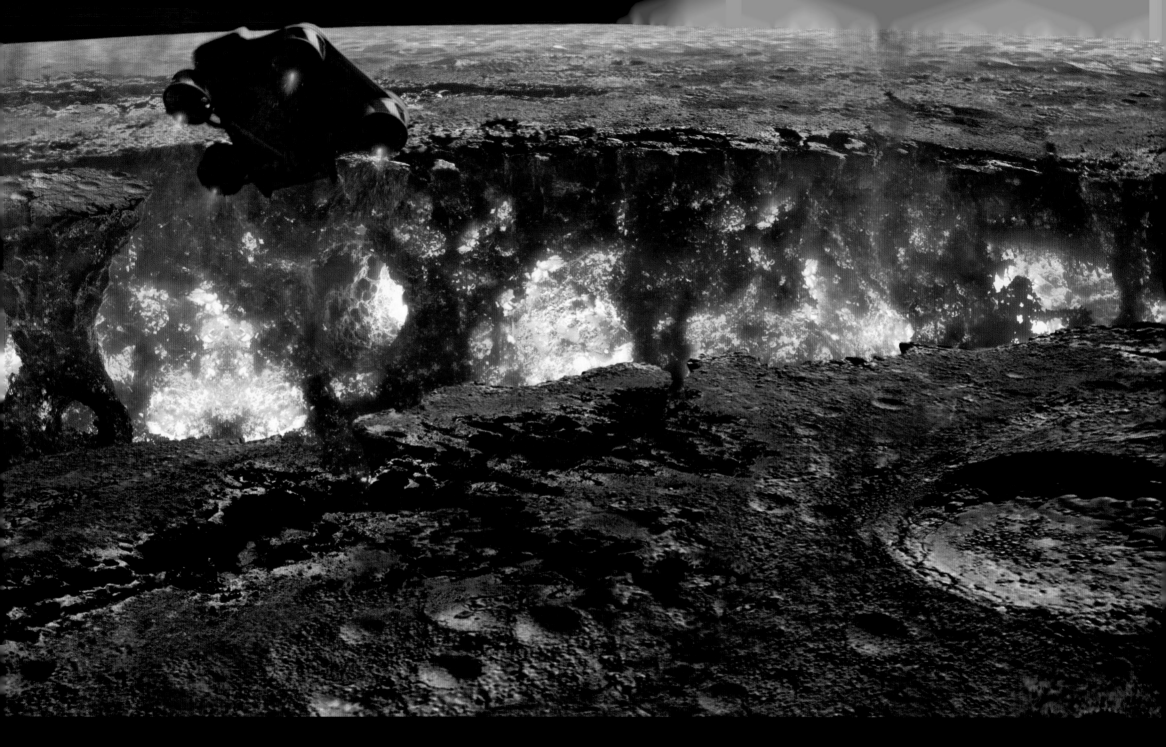

Following the leader, ROC 1
descends into the crevasse
to document the *Lowell* and its surroundings.
Even though it is in autonomous mode, Brooks can still give it verbal commands while he pilots his craft.

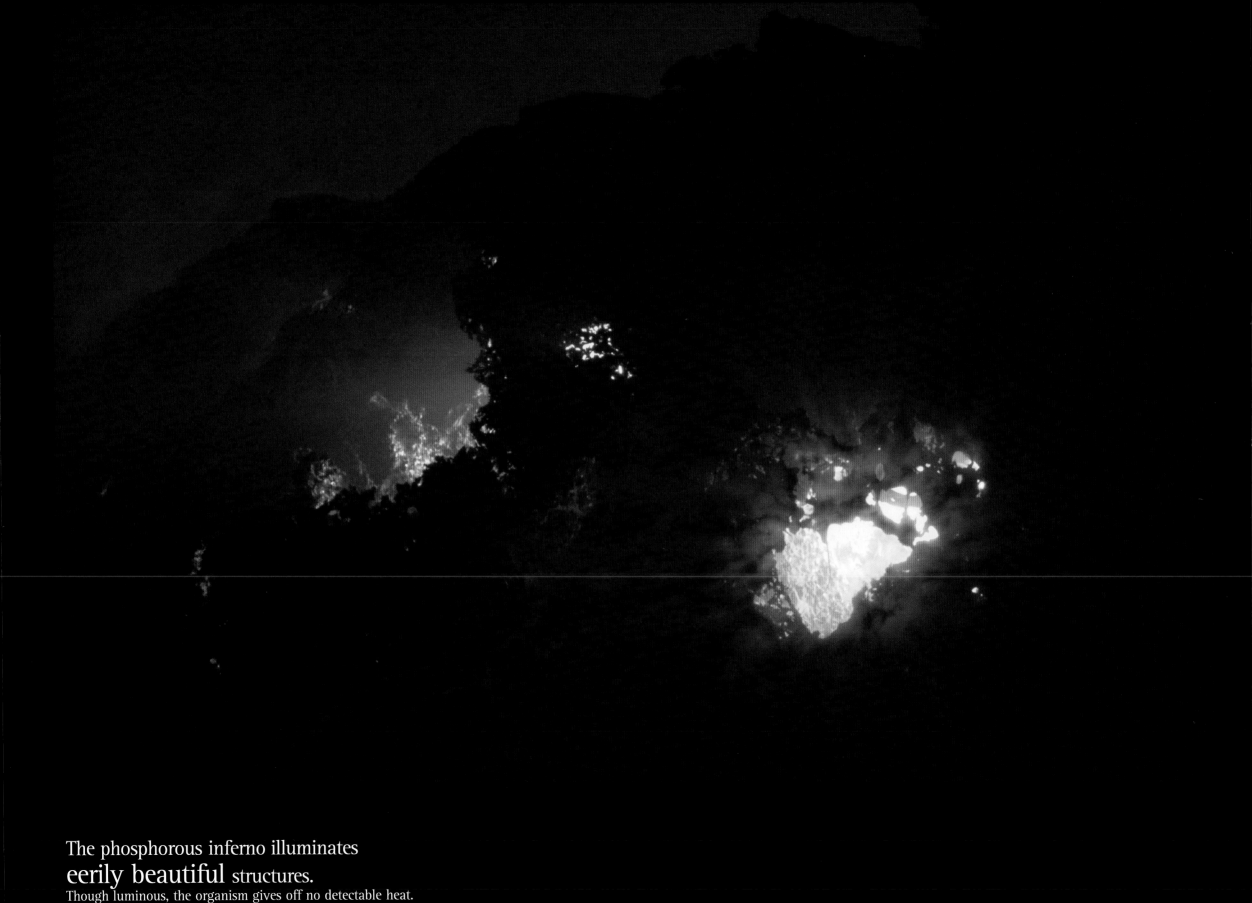

The phosphorous inferno illuminates
eerily beautiful structures.
Though luminous, the organism gives off no detectable heat.

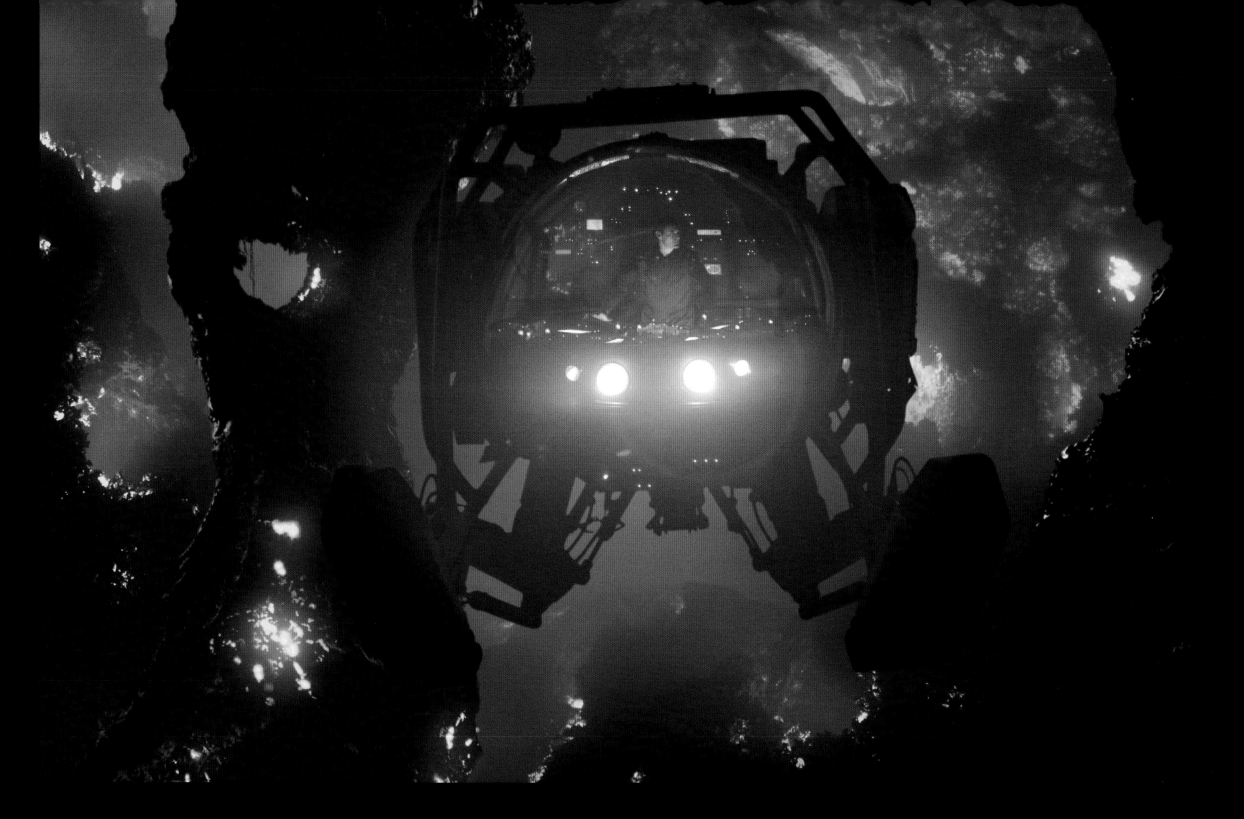

Navigating the treacherous maze
of infected rock,
Brooks looks for an unobstructed exit passage,
while the *Lowell* collects data. The pulsed data stream reaches Mission Control in about one month, but scientists will interpret the information for years.

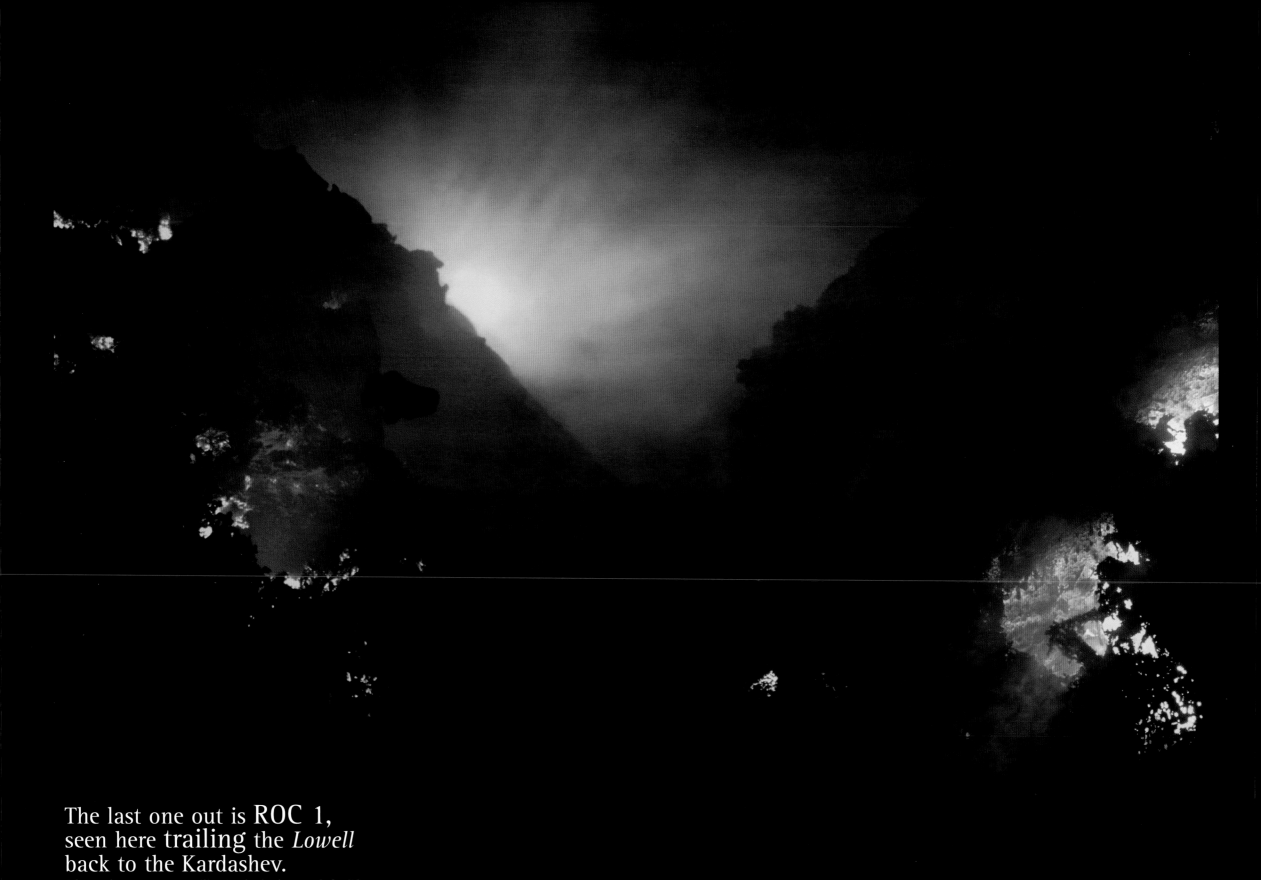

The last one out is ROC 1,
seen here trailing the *Lowell*
back to the Kardashev.
After a plasma-stream sterilization bath, the search for life
in the Proxima Centauri system will continue.

Proxima Centauri 6 In the Realm Ethereal

An unlikely place to live, yet the readings from Proxima's sixth world indicate the presence of life.

This is a sub-Jovian gas planet whose atmosphere is made up mostly of nitrogen and methane, along with traces of water vapor. Its cold and inert rocky core lies submerged under a sea of liquid hydrogen. Above, turbulent weather systems create bands of gas clouds that race around the planet, while others seem to hang listlessly. Although the volume of the planet is huge, its actual mass is less than that of Earth, resulting in less than half of Earth's gravity. Life-forms that exist in this harsh environment have evolved very specific survival features.

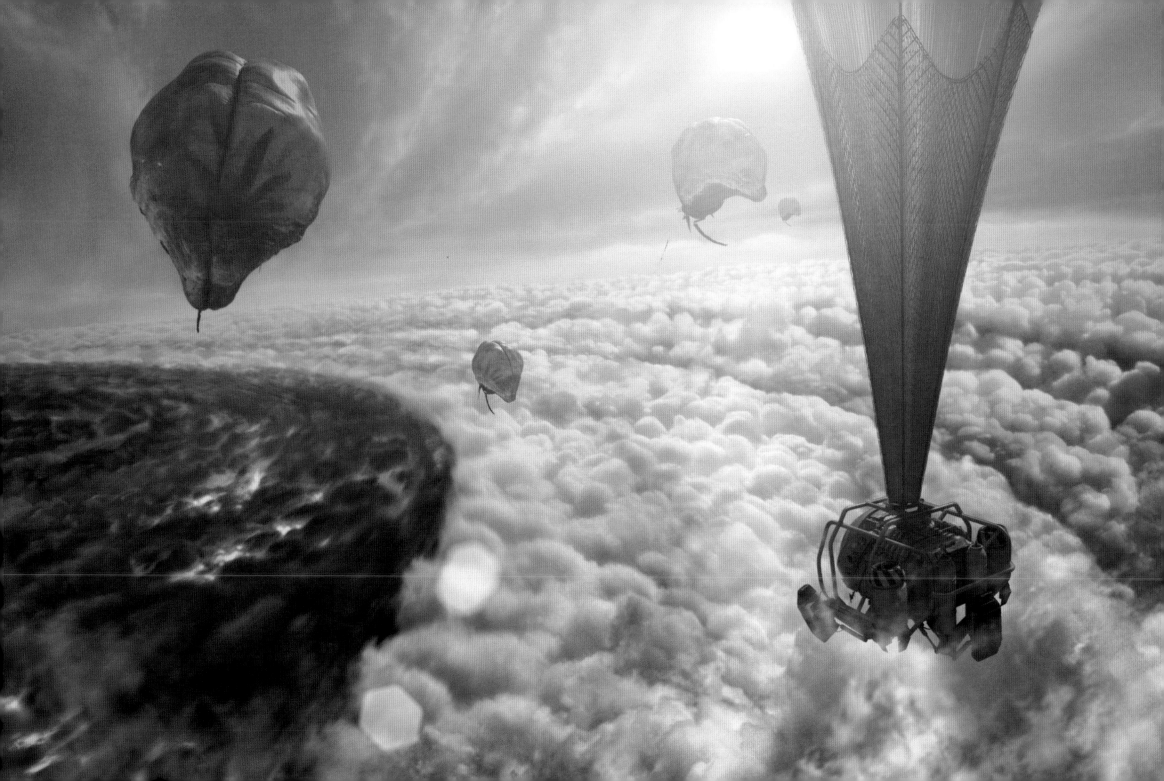

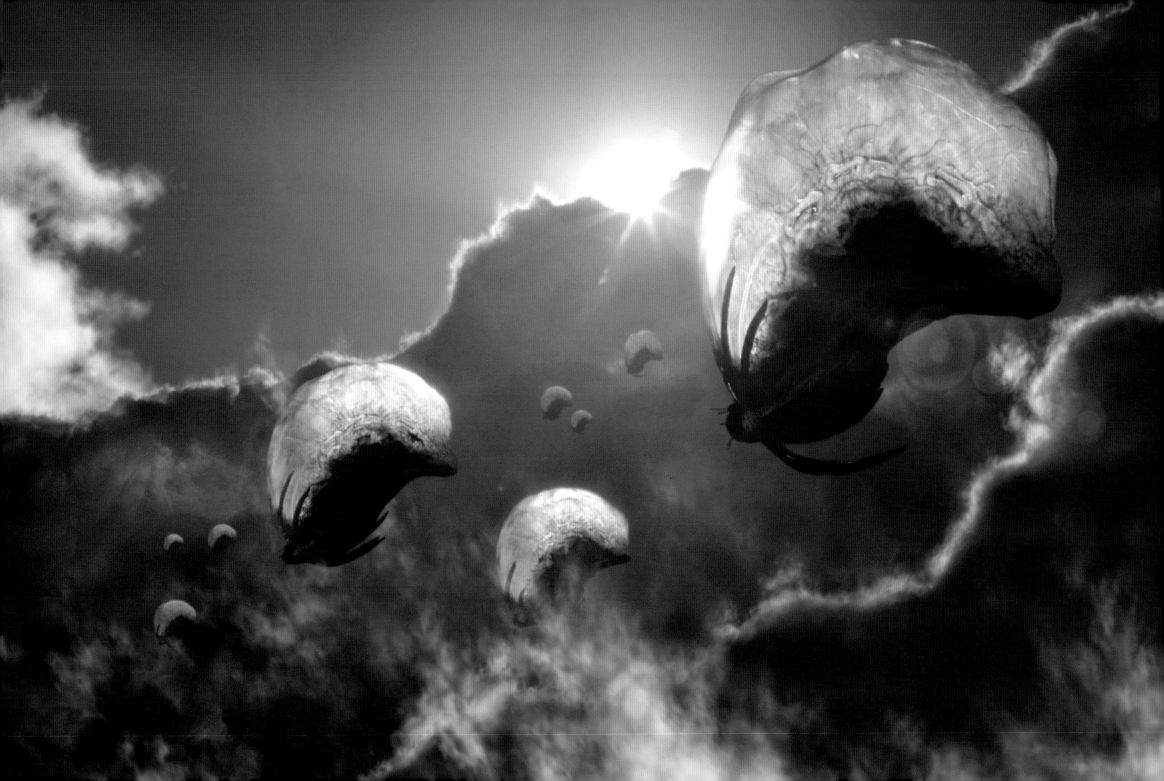

"*A younger member of the* pod
was particularly interested in my support balloon.
It circled for hours,
occasionally nudging it as if...[looking] for a response.
Whether it saw its own reflection or sensed a kindred soul, I do not know."

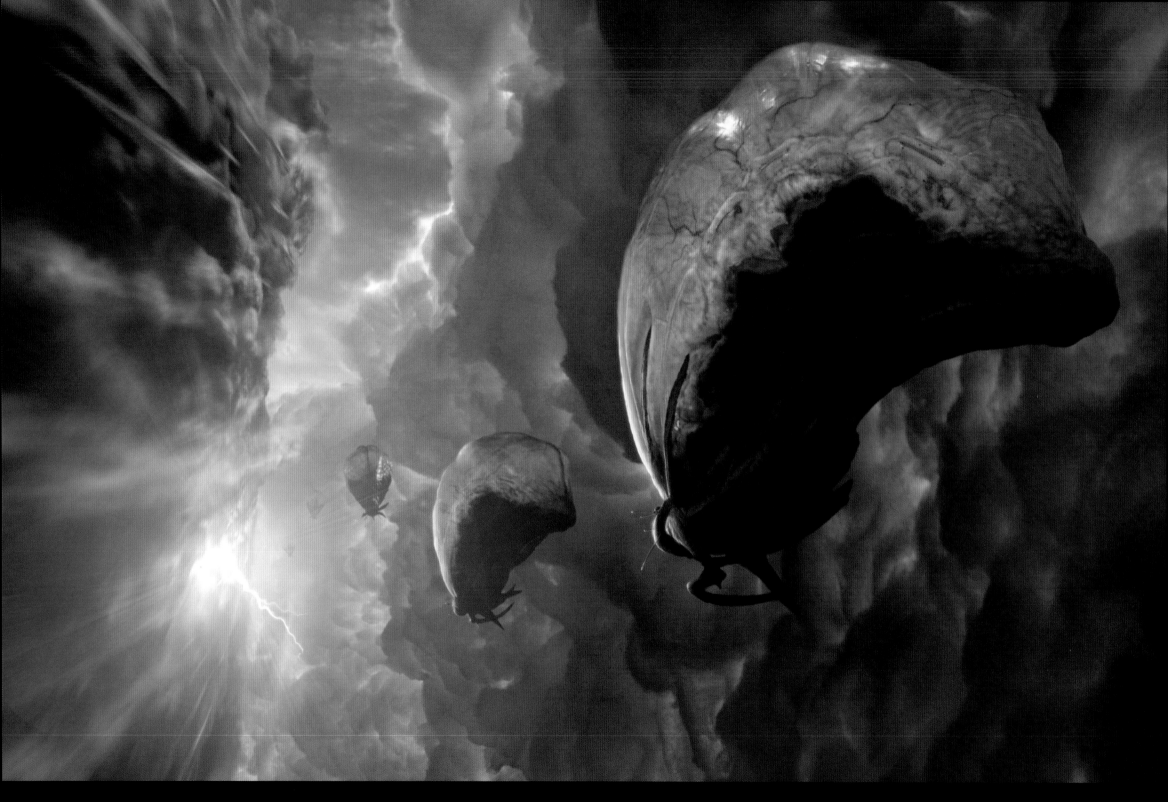

Adrift between heaven and hell, *Caelestis Scarabaeus* navigates the dead calm of a cloud canyon.

Billowing cumulus clouds of ammonia and ice crystals hang harmlessly on one side, while a cyclonic storm with 700-mph winds rages violently on the other side. Arcing bolts of lightning from within it can mean death to *Scarabaeus*, whose bodies generate the flammable hydrogen that keep them aloft.

At rest in the heart of the maelstrom, the pod hibernates at the rocky core of the planet, with their flight sacs deflated and stowed under their carapaces. *Scarabaeus'* pitonlike claws hold them firm against the powerful currents of the liquid hydrogen sea. It is believed that during this hibernation period the creatures replenish their hydrogen supply. ROC 1 scans this image but is unable to withstand the pressure, which is equal to 7,500 Earth atmospheres. A crack in its titanium-infused Kevlar hull causes it to malfunction, and it is swept away into oblivion.

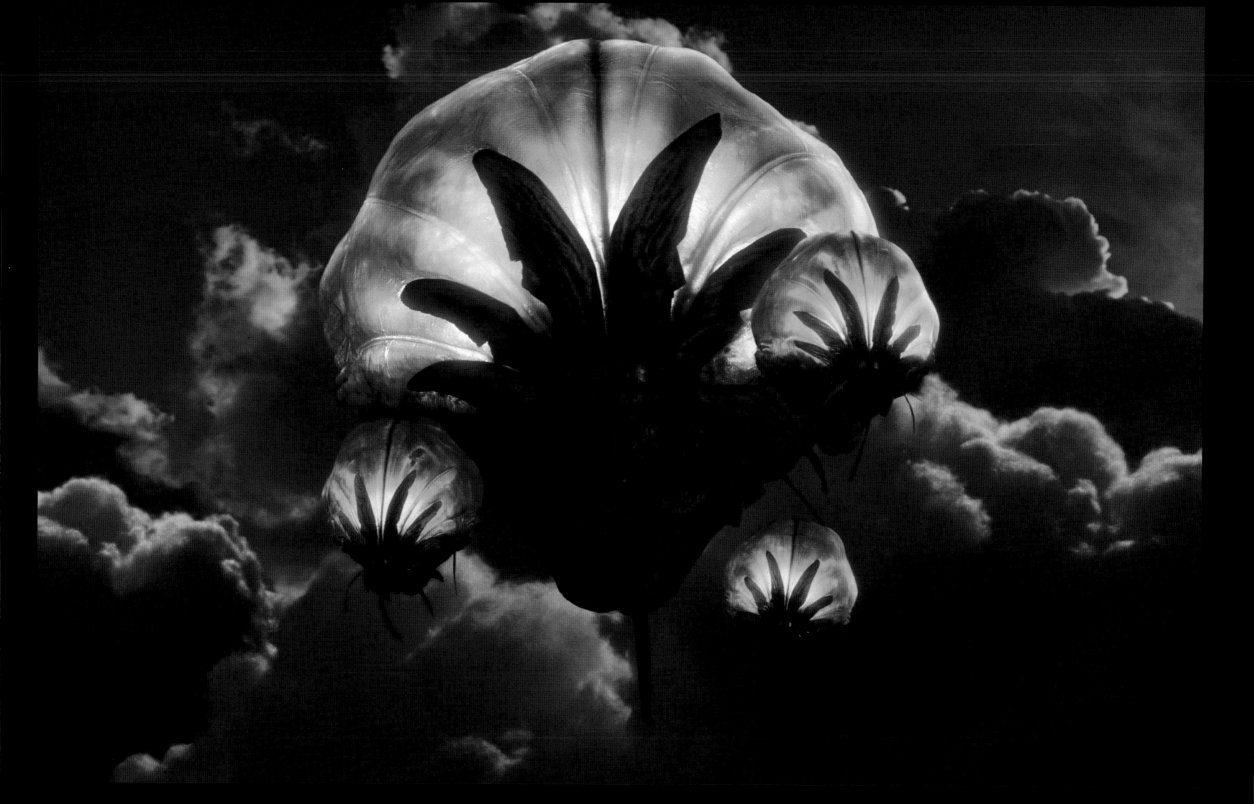

Aglow like Chinese lanterns, nightfall stimulates the bioluminescence of *Caelestis Scarabaeus*.

This effect might be a way for members of the pod to locate each other in darkness, or perhaps they detect a chemical reaction and illumination is merely a by-product. Whatever the mechanism, three subadults hover near their elder and occasionally nuzzle close enough to insert a siphon into the valves of its flight sacs and extract hydrogen.

"It appears that the adults of the pod help keep their offspring aloft until their hydrogen-producing abilities develop. They are as different from us as they can be, yet we share the same instinct of caring for the young."

Proxima Centauri 4 Life Abundant

Islands of life dot the equator with almost **perfect** symmetry on the fourth planet from the star Proxima Centauri.

The appearance of green haze elicits hoots of excitement from anxious scientists and technicians when the first low-resolution images of this world appear on the wall-sized screens at Worlds Mission Control. As the scans come into focus, the sounds of joy are replaced by an awed hush. How did areas of dense vegetation take hold in this inhospitable geothermic landscape? What geologic conditions led to the seeming order of their location? By the time Mission Control asks these questions, Brooks and the *Lowell* are already one month into the search for answers.

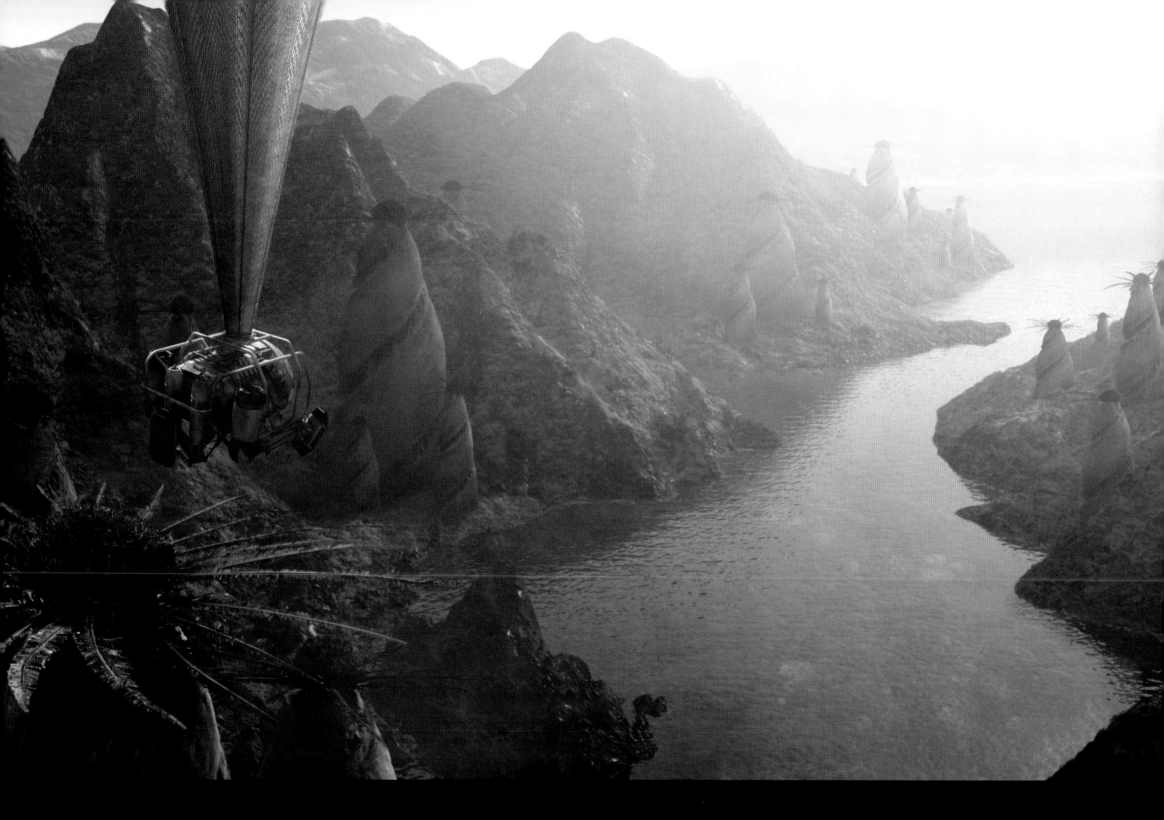

"As I descended toward this alien jungle, *I was struck by both the amazing familiarity and complete otherworldliness of it all.*

The comforting green of the foliage certainly meant the presence of chlorophyll...but those monumental...trees! I guess that's what I'd call them; some must be twice the size of a Sequoia." Brooks also notes that the blanket of foliage can't hide the rough-hewn volcanic origins of the topography. Sonar soundings show that the lakes, rivers, and even small streams are deep crevasses formed by constant tectonic shifting

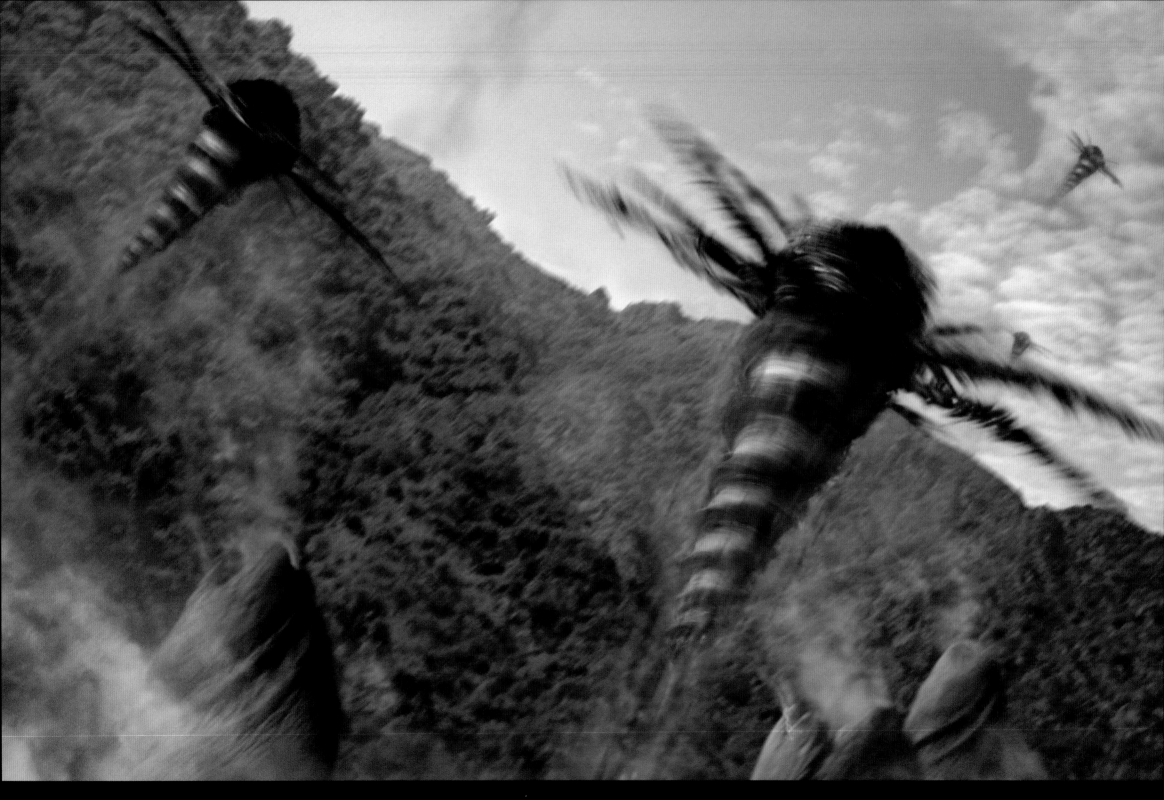

Caught in the line of fire, Brooks evades an unexpected barrage of gigantic airborne seedpods.

Nestled in a hollow chamber atop the monolithic plant, the pods explode skyward when the reservoir fills with pressurized gases. The 70-meter spread of the propeller-like fronds helps provide the lift that carries the pod far from its parent plant, where its chances of survival are greater. The evolutionary design of the pod itself increases the seedlings' chances as well.

"Upon hitting the ground, the seed's corkscrew shape enabled it to burrow deep into the soil where it will have less competition for water and nutrients. As an extra measure, I saw the spinning fronds mow down surrounding foliage, creating a competition-free growth zone. A near perfect design!"

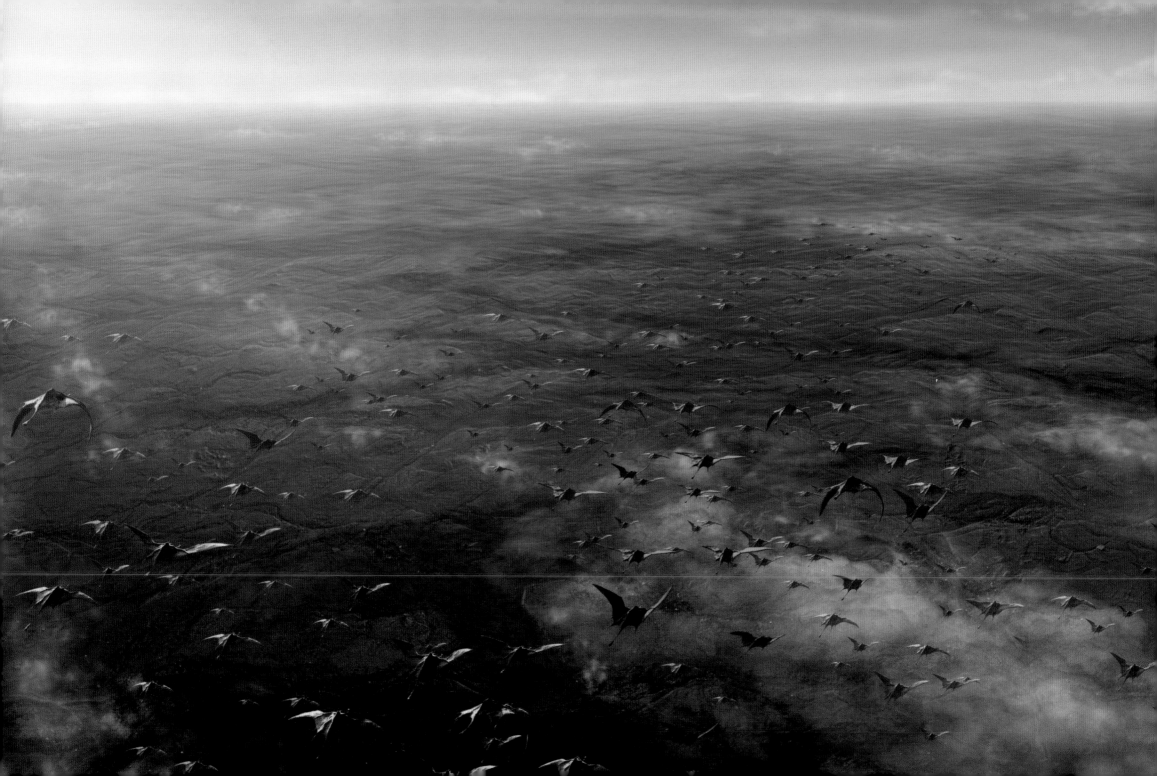

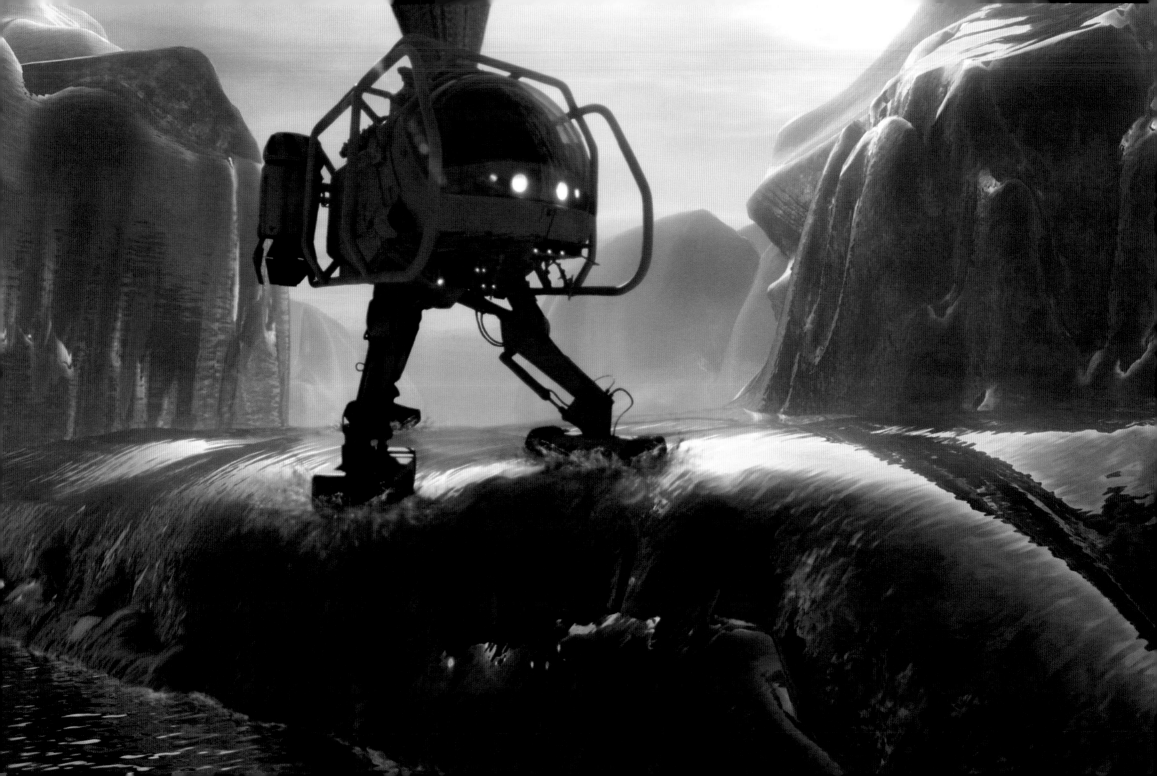

Spectral beings haunt a liquid world and are illuminated for an instant by ROC 2s spotlight. At about three meters from fin tip to fin tip, these powerful swimmers propel themselves through the water with kicks from their four sinewy appendages, which are each tipped with a broad paddle. *"At first it seemed odd that that they paid no attention to the ROC, especially with its light on. It didn't take long to figure out why. They were being chased."*

A big fish in a small pond,
Aquatilis Gigantus reaches a length
of 250 meters, yet its home, the Southern
Polar Sea, is only about the size of Texas.

Sonar mapping of the ocean floor's erosion reveals a relatively young body of water, perhaps only 200,000 years old. The emergence of a creature this large in such a short period of time challenges our precepts about evolution.

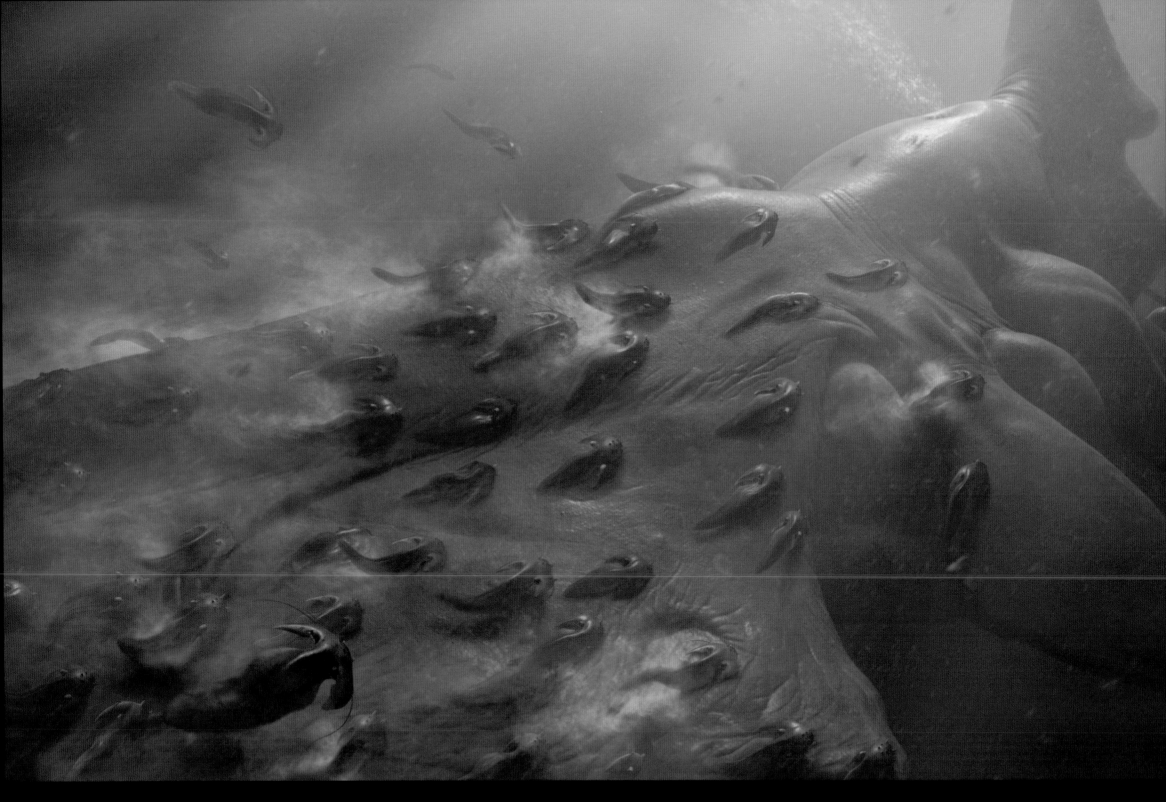

Along for the ride, the males of the species cling to the body of the larger female *Aquatilis* and release clouds of sperm in a haphazard effort to procreate.

They seem to have no instinctive awareness of where the female's reproductive organs are, so the fate of the next generation depends on whether enough discharge gets to the appropriate orifice. This explains why there are so many males and why their evolutionary role is essentially that of a sperm delivery vehicle.

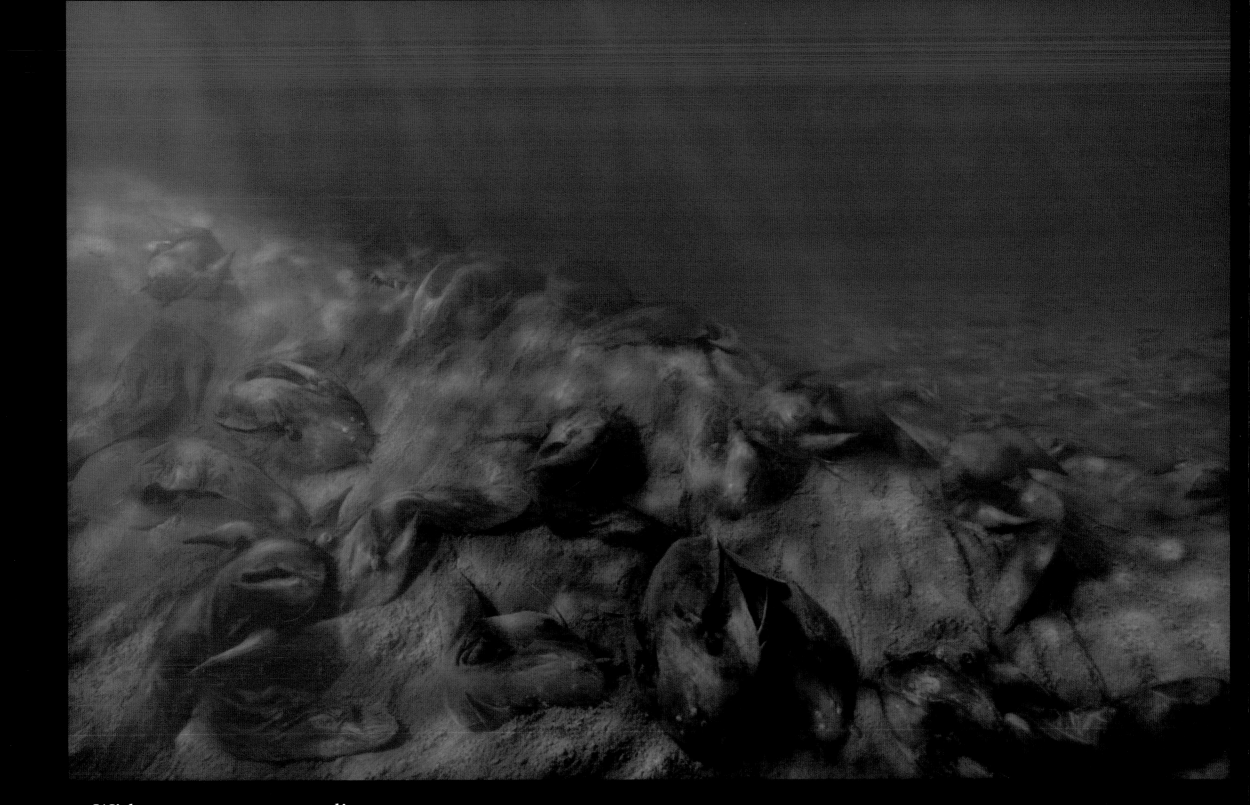

With no more reason to live,
the **carcasses** of spent

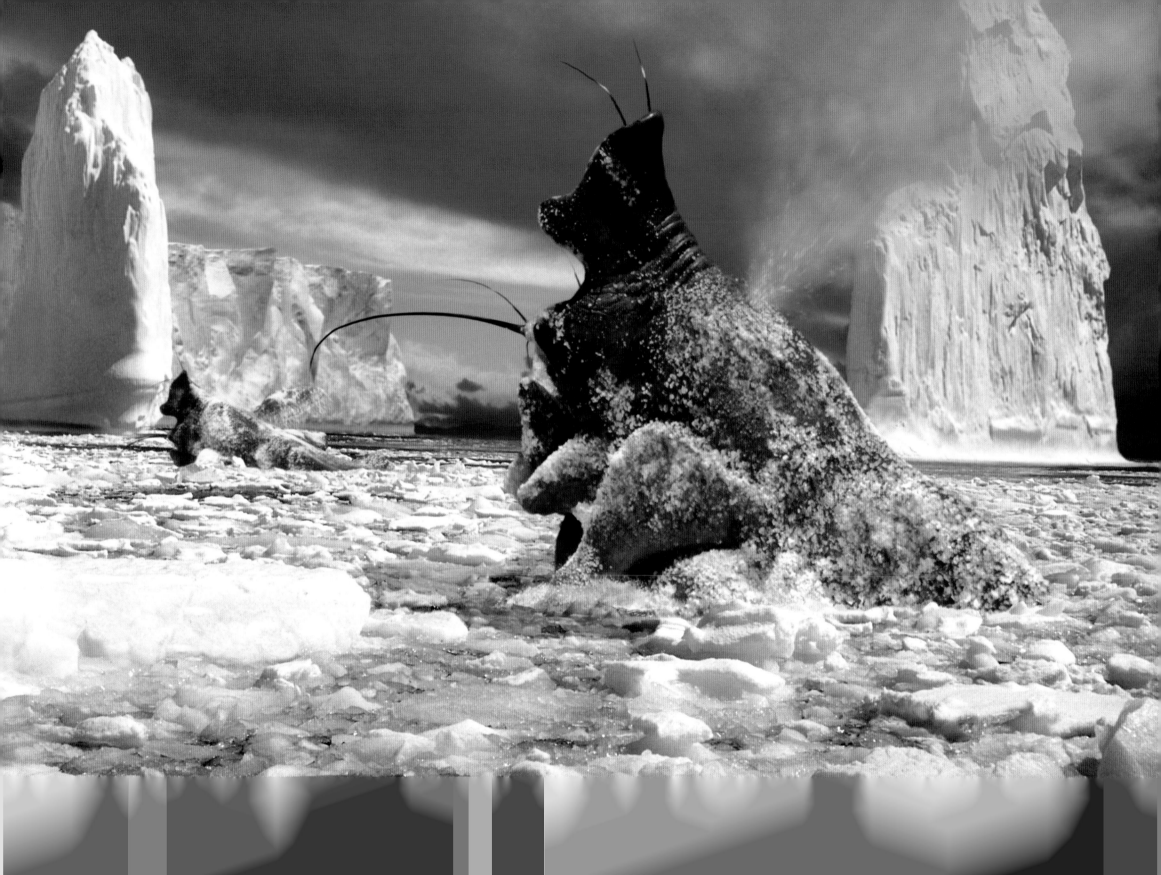

Some see a hell incarnate,
but the geophysicist sees a planet under constru
The mystery of Proxima Centauri 4 is how complex life-forms could evolve so c
of such unstable geologic conditions.

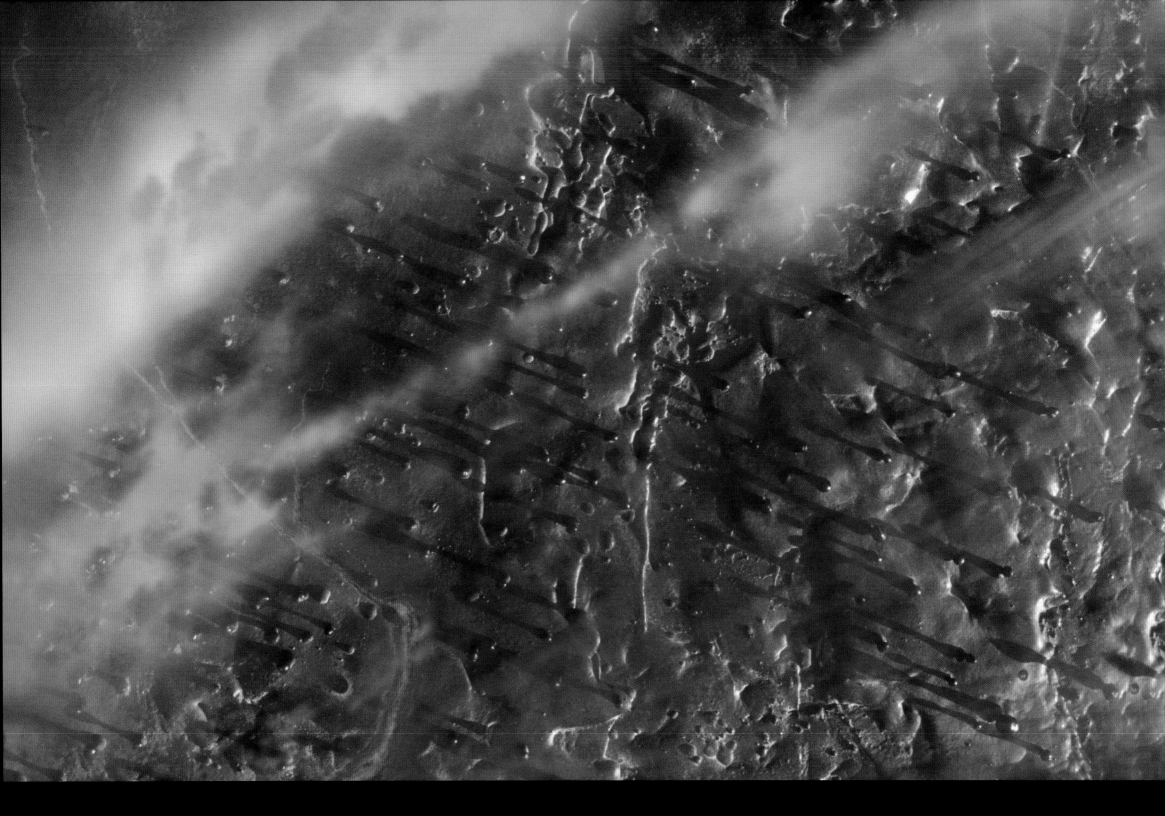

*"...interesting shadows cutting
across the **scarred face**
of the Great Lava Basin...*
hope to check them out later."

"I'm fascinated by the steep angle of some of the **stratovolcanoes.** No scree slopes or other indications of age...possible that they are young [and] formed in a single cataclysmic eruption."

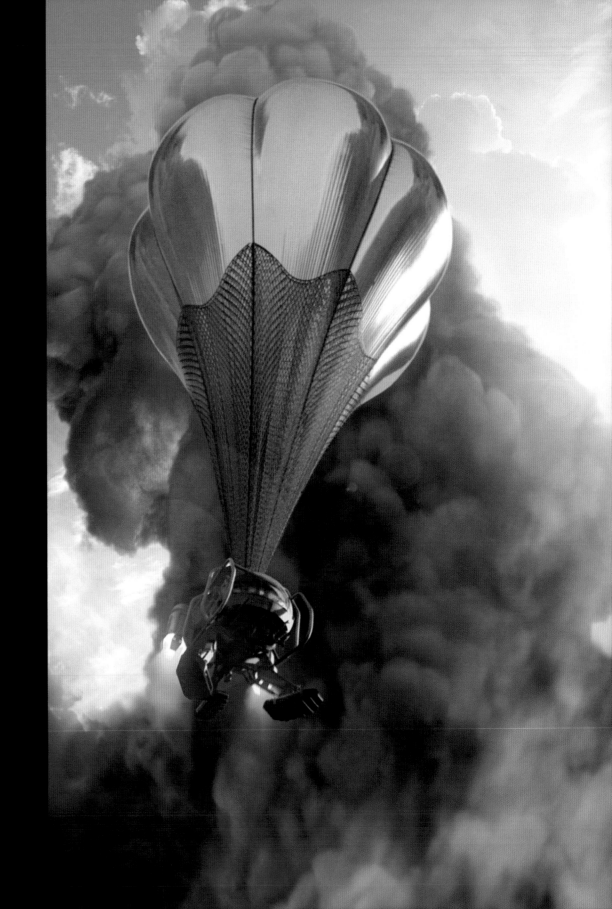

Like Icarus flying too close to the heat of the sun, a sudden shift of wind pushes the *Lowell* into the volcano's *nuée ardente.*

While fighting to reorient the craft, Brooks loses time by reacting to the ship's warning of a pressure change in the lava dome below.

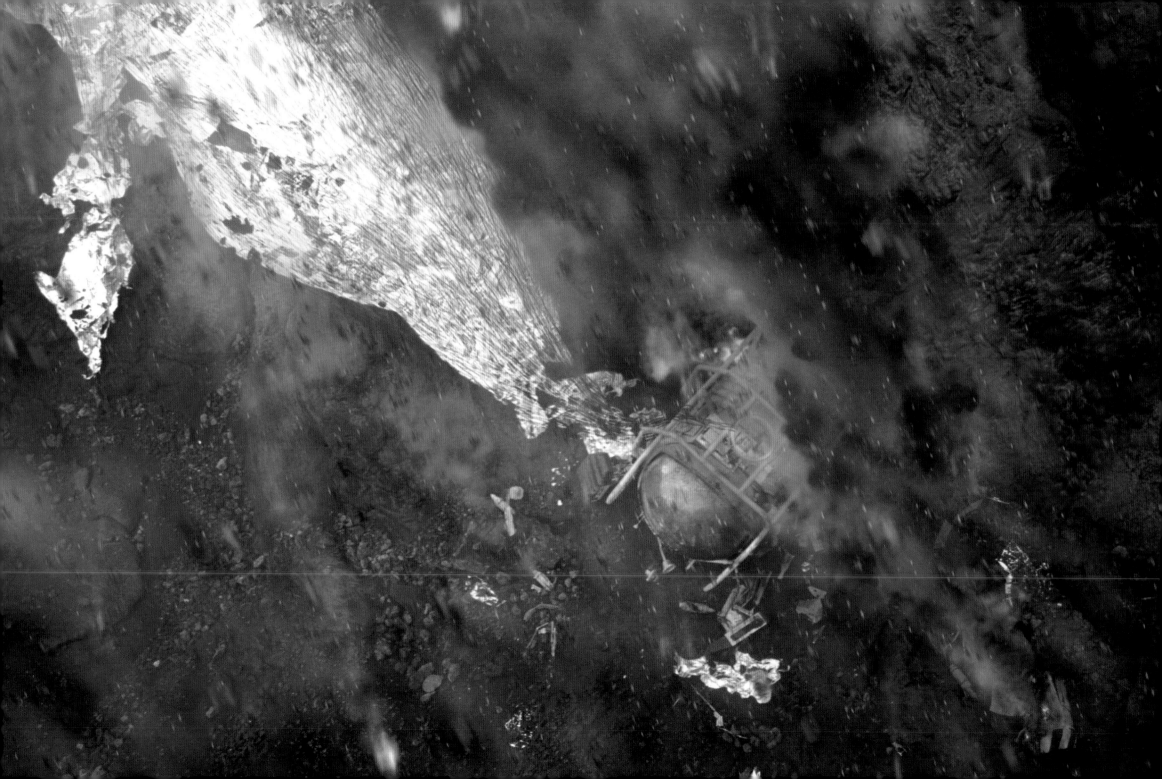

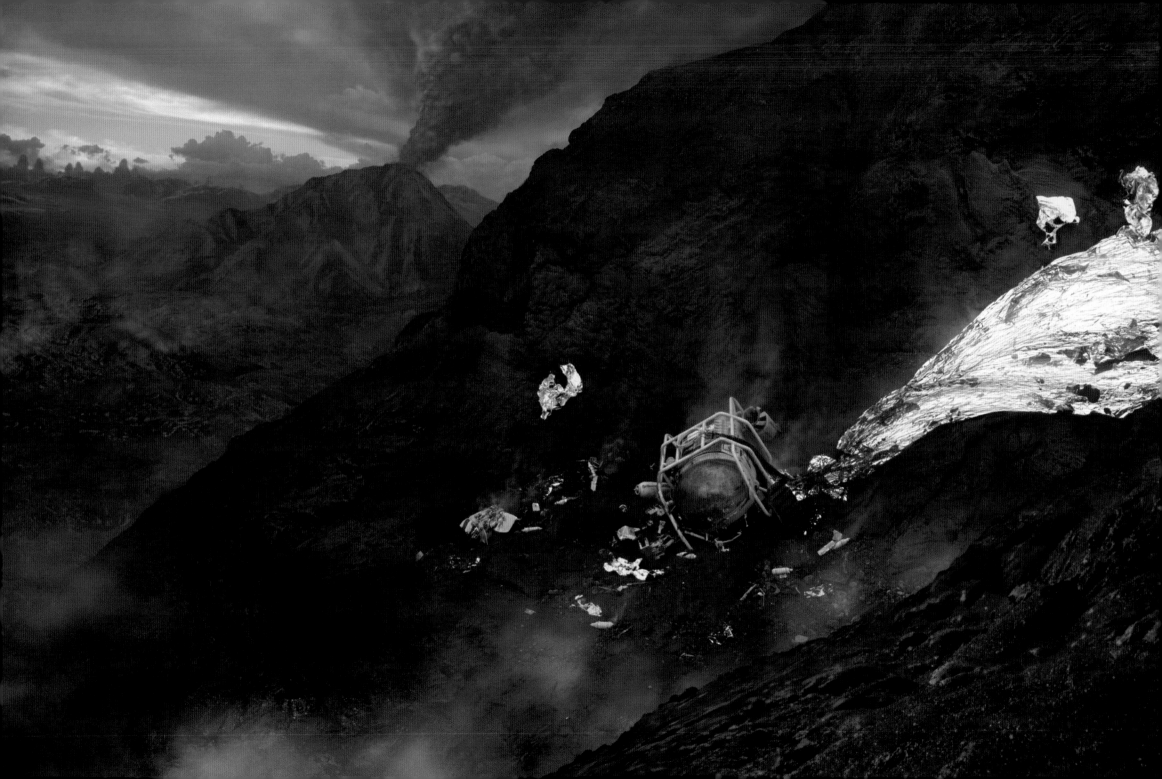

Marooned

Beyond repair, the right main thrust engine lies in a heap 100 meters from the downed *Lowell*

The ship rests at an altitude of about 4,000 meters, where the atmosphere is thin though breathable. Despite using a small oxygen tank, Brooks is exhausted from the exertion of gathering parts of the *Lowell's* wreckage. The ship's medical telemetrics determine that Brooks has to stay inside the *Lowell*, which is still able to prod~~uce oxygen for~~

20 minutes every two hours, or risk the onset of pulmonary or cerebral edema. This limits his ability to make research forays of any great distance.

"*I am down, but not out. I will continue the mission as best I can. Do not awaken my wife. Repeat...do not awaken my wife.*"

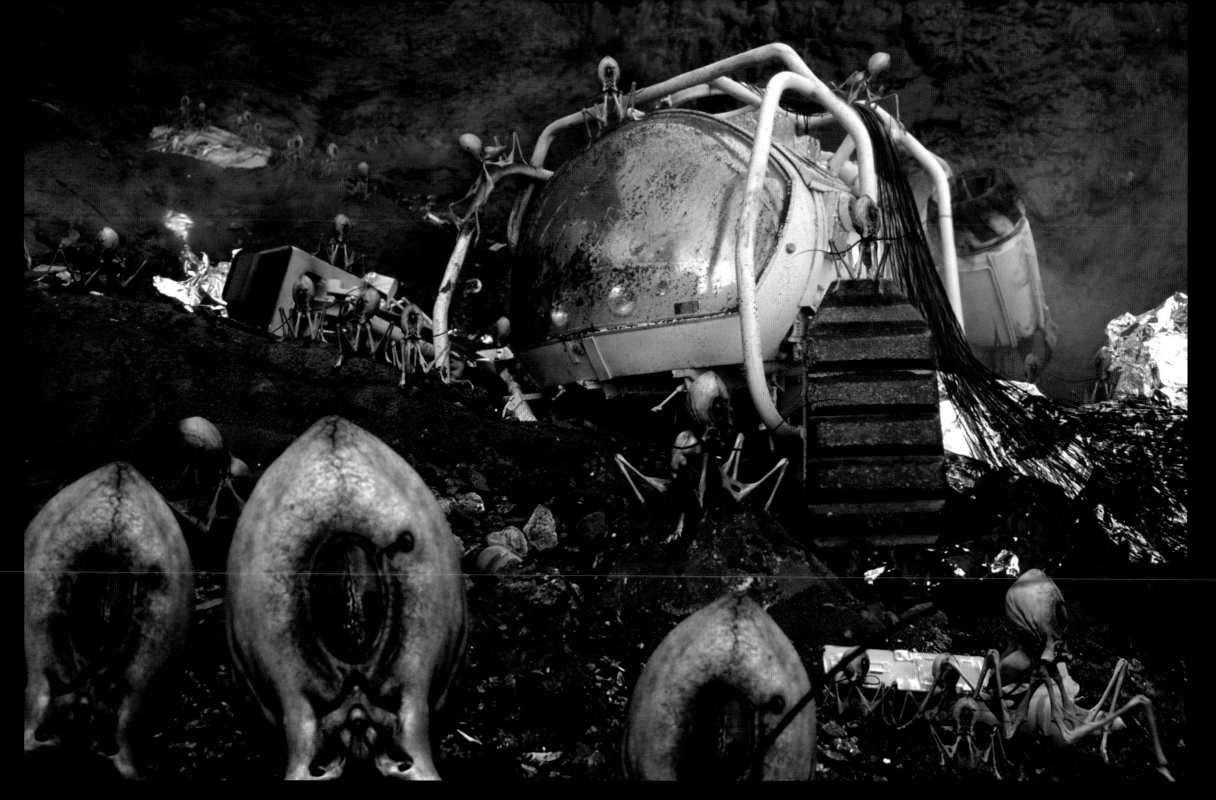

"I awoke on the third morning after the crash and stepped outside the Lowell.

To my shock I found myself surrounded by a horde of bizarre stilt-legged creatures about 1 meter high. They showed sign of aggression, and their initial curiosity wore off quickly. My guess is that their disinterested demeanor comes from having no natural predators in this harsh environment. Perhaps this lack of competition has limited their brain development too. They seem just plain dumb."

Much of the *Lowell's* instrumentation is destroyed, but communications are still intact, as are most of the life-support systems. Brooks decides his best option is to stay with his ship until a rescue mission is mounted—at least a five-year wait.

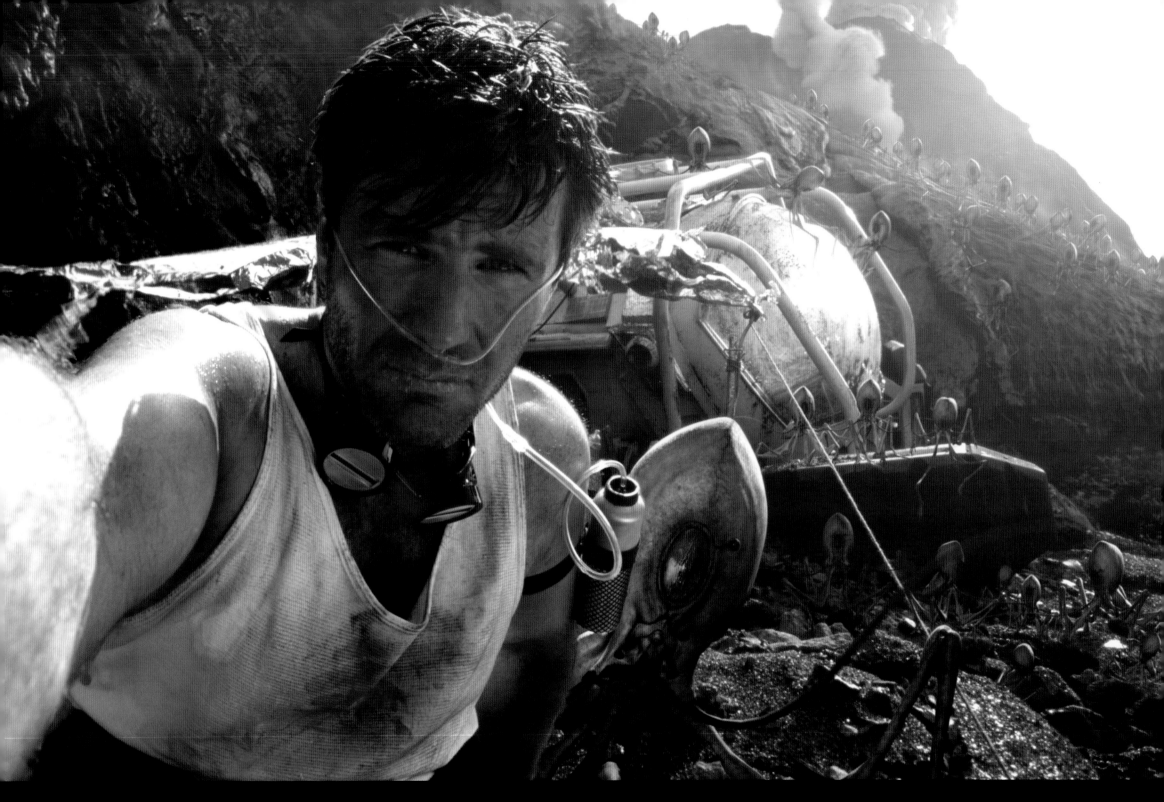

Much of the ship's instrumentation has been damaged...evap kit intact, thank God...am in a constant state of anxiety, living in the shadow of that volcanic ash plume. Frequent temblors make sleep difficult. I will continue my research...especially interested in my newfound companions whom I have named Arachnomimus."

"It has been *six weeks* since the Lowell was downed.

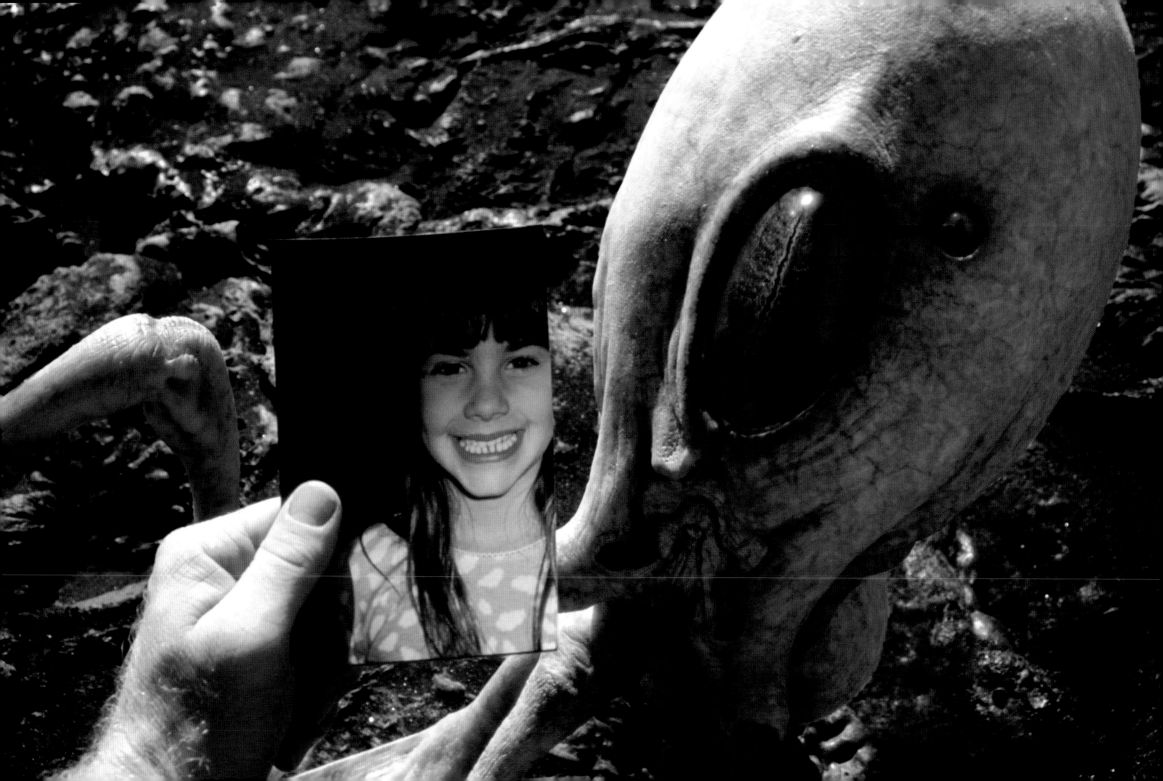

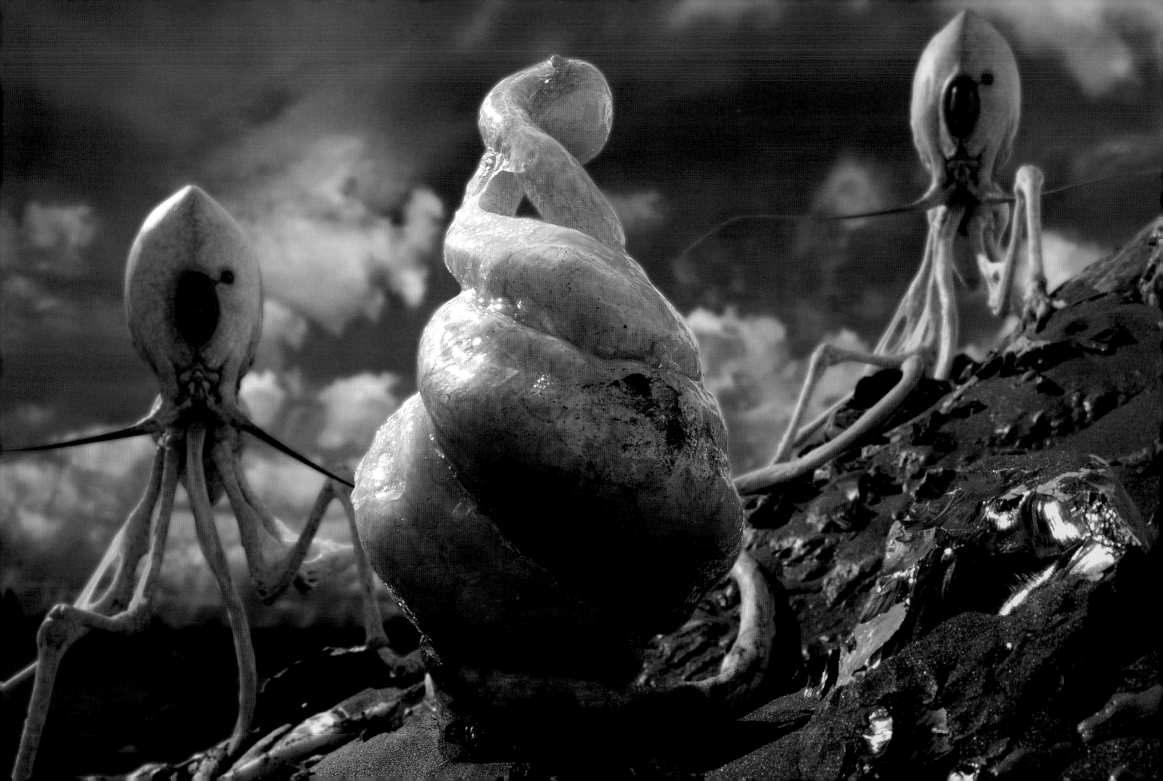

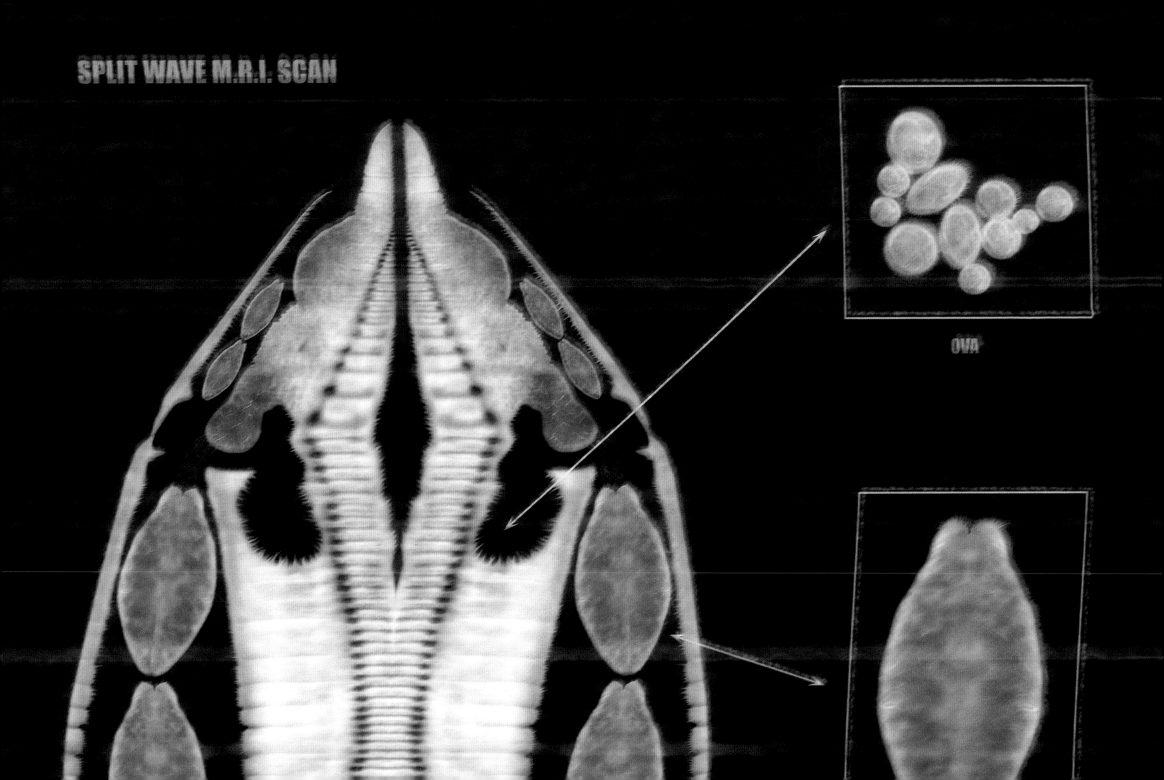

SPLIT WAVE M.R.I. SCAN

OVA

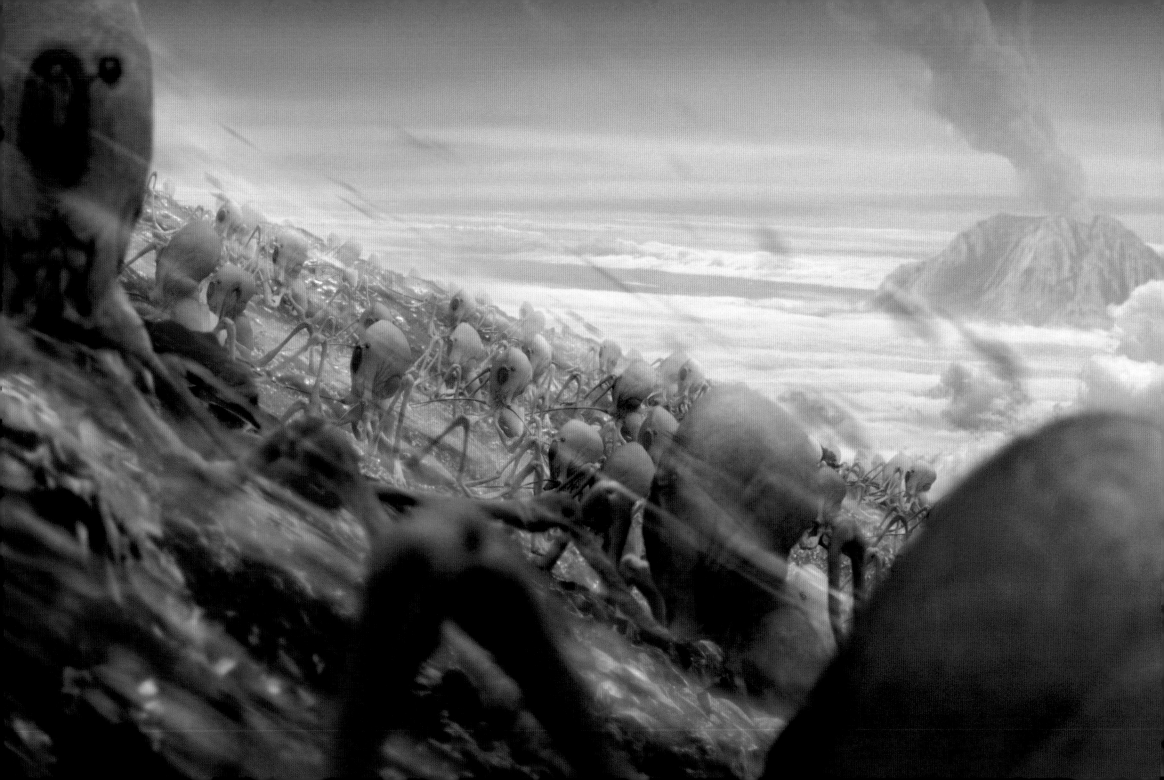

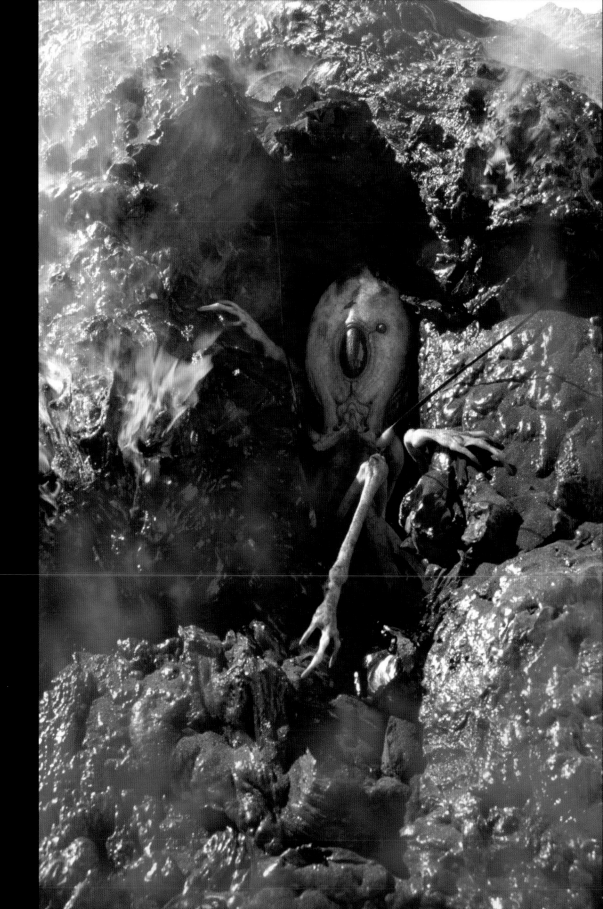

Finding a warm nest is a painstaking process
 for this expectant *Arachnomimus*, who spends hours
crawling in and out of holes and crevasses
 looking for the right nursery.

The creature's three-week gestation period must be physically draining, as it goes into an energy-conserving
hibernation during the process. At the end of that, exactly six offspring are produced; never more, never less.

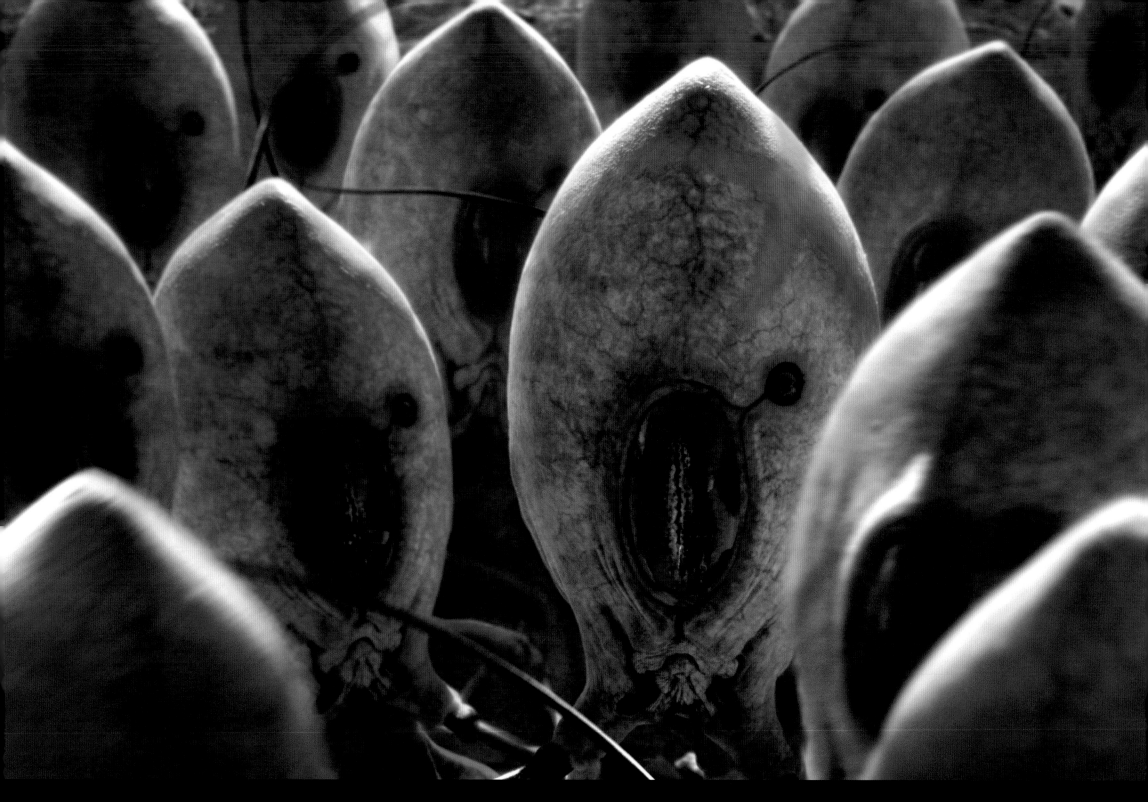

"...the constant presence of these creatures has become part of daily life.

Some mornings I find the Lowell's door blocked by a gag-

night's wind. They seem oblivious to me. Even after nudging them with my boot, I have to actually pick them up and move them! If we were hoping to find intelligent life, these guys don't qualify...There is an exception—one of them seems curious about my activities, and I've marked him with an "X" to tell him apart from the others. This is

important considering that my food supplies are dwindling, and I need to consider a supplemental source..."

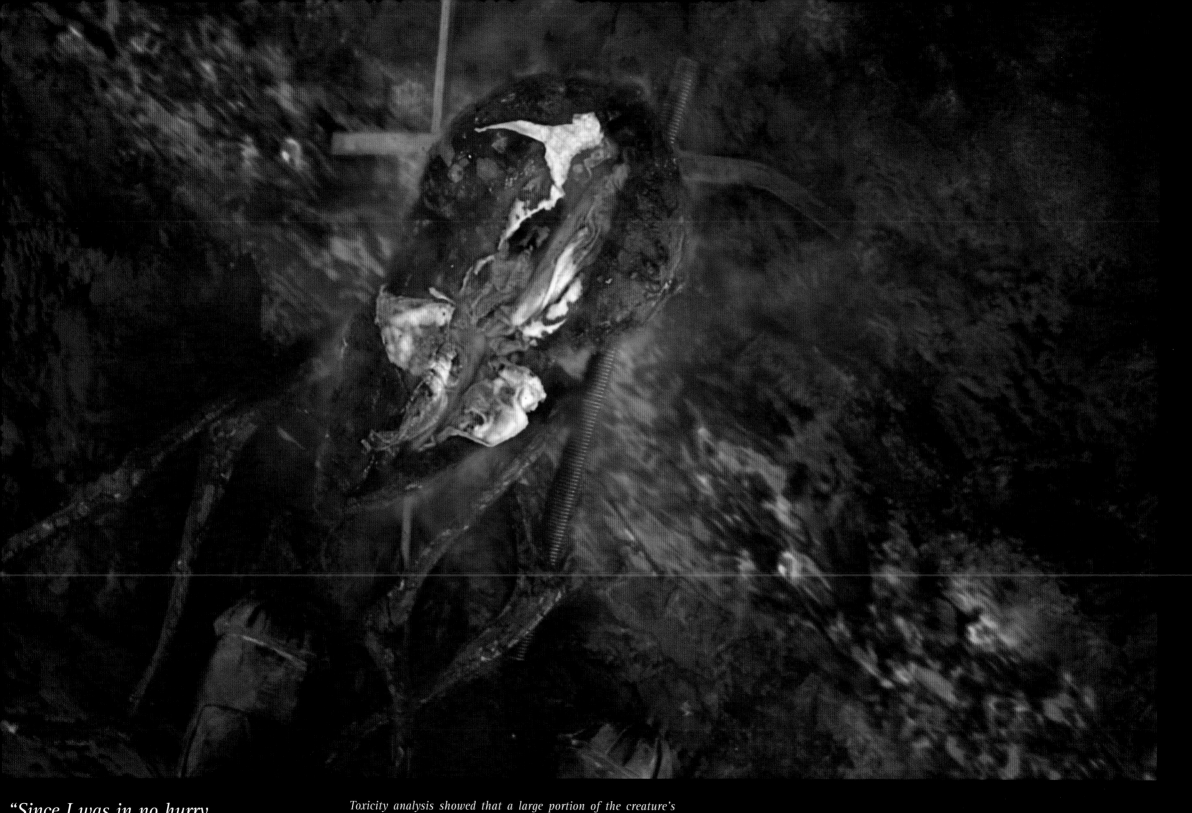

"*Since I was in no hurry,
 I waited until one died, then ran
some tissue tests to make sure the*
~~~~~~ disease-free

Toxicity analysis showed that a large portion of the creature's body was incompatible with my digestive system, so I carefully avoided those areas. Even so, after eating I became violently ill, suffering nausea and hallucinations for two days. I discovered that the only edible tissue is the facia between the skin and mus-

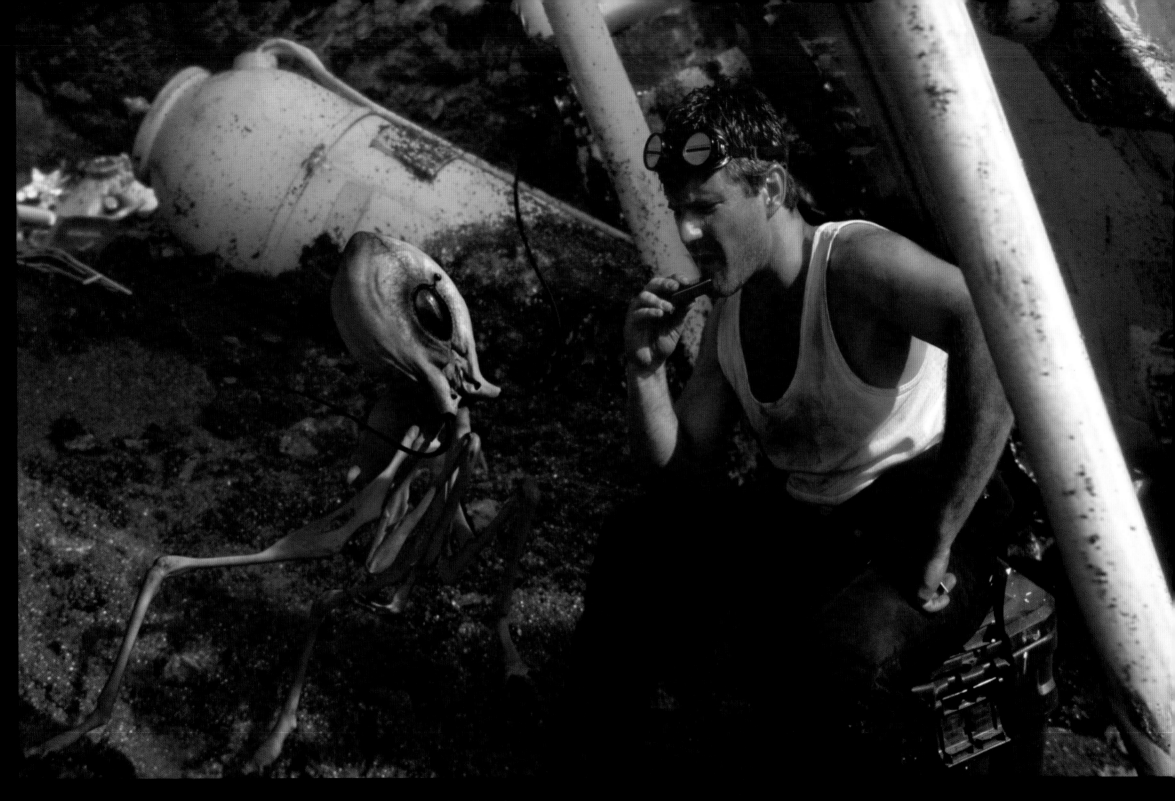

The foreign act of shaving during Brooks' **morning regimen** draws attention from the most curious *Arachnomimus,*

It is Brooks' singing that elicits the most extreme response, however. X-ey burrows under wreckage and emerges an hour after the singing stops. *"I get the same reaction from my daughter."*

Survival

"...managed to save some remnants of the **Mylar balloon,** a few supplies, and ROC 2 before my vessel was **overtaken.**

Mylar wrapping should keep me safe from the searing volcanic heat...placing all hope in reaching the greenbelt to the south. Any place should be better than here. I will continue to research and transmit. You will receive this in about a month...please do not awaken my wife from cryo sleep. Not yet."

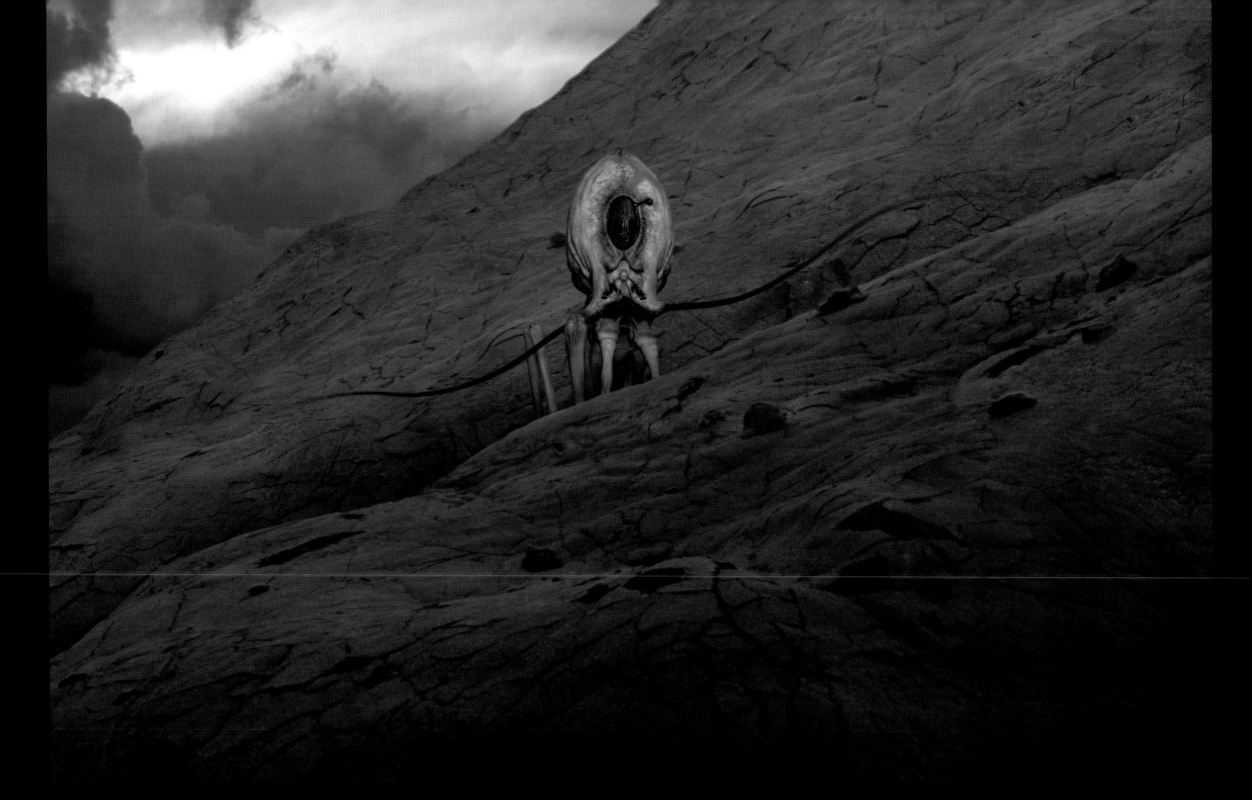

A sad farewell comes from one of the few Arachnomimus that was not killed in the eruptions that claimed the *Lowell*

X-ey follows Brooks 1,000 meters down the mountainside, until abruptly stopping. Perhaps sensing a change in air pressure or temperature, the creature instinctively knows it cannot survive below that level.

"I could coax it down no further...it stood in one spot, swaying and emitting a series of staccato chirps, crying I

would say, but perhaps I was projecting my own emotions onto it. As I turned and left X-ey to his volatile home and headed toward the jungle, I wondered whose fate was the more uncertain."

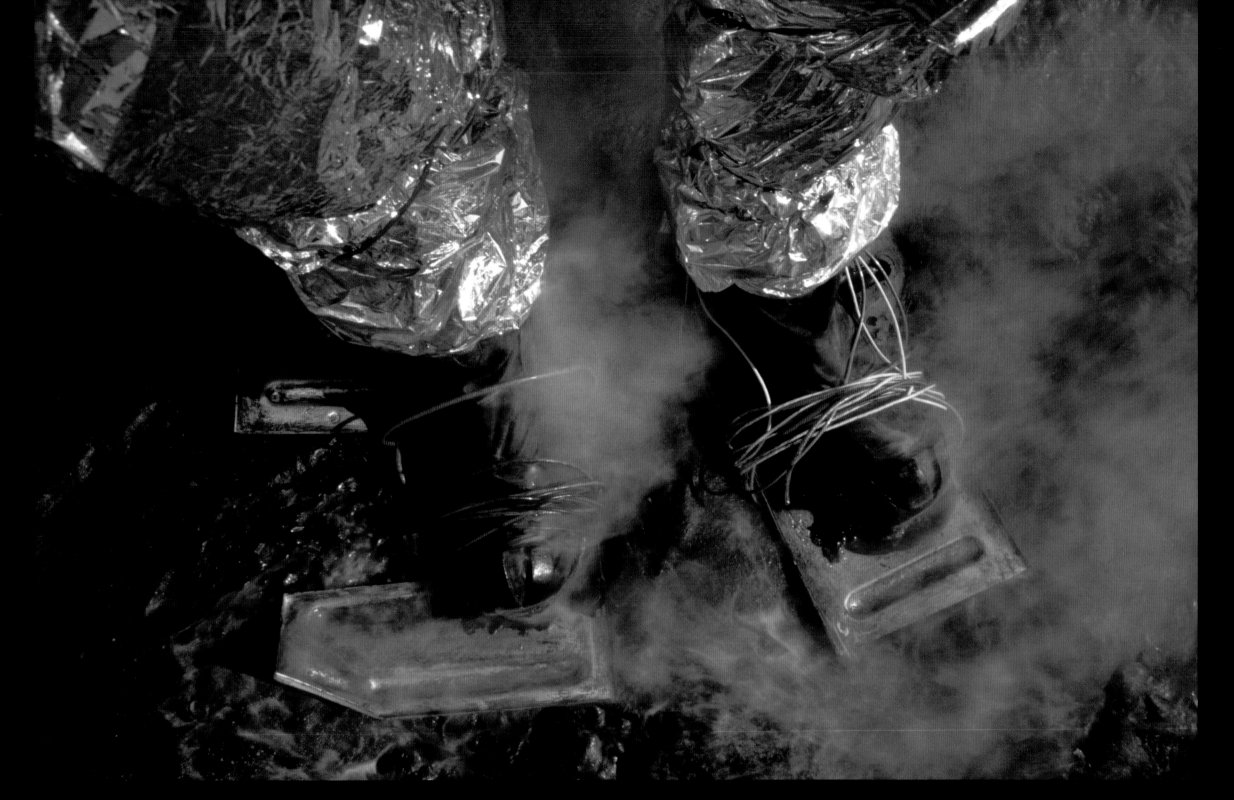

The last vestiges of the *Lowell* are strapped to Brooks' boots as **protection** from the volcanic terrain's heat.

Walking across the Great Lava Basin is a harrowing experience. Treacherous pockets of magma hide beneath thin crusts of hardened lava, clouds of toxic gases drift by, and stagnant pools of acid are constant threats. Brooks uses high-altitude scans from ROC 2 to help guide his path to the Tropical Rain Forest Biome.

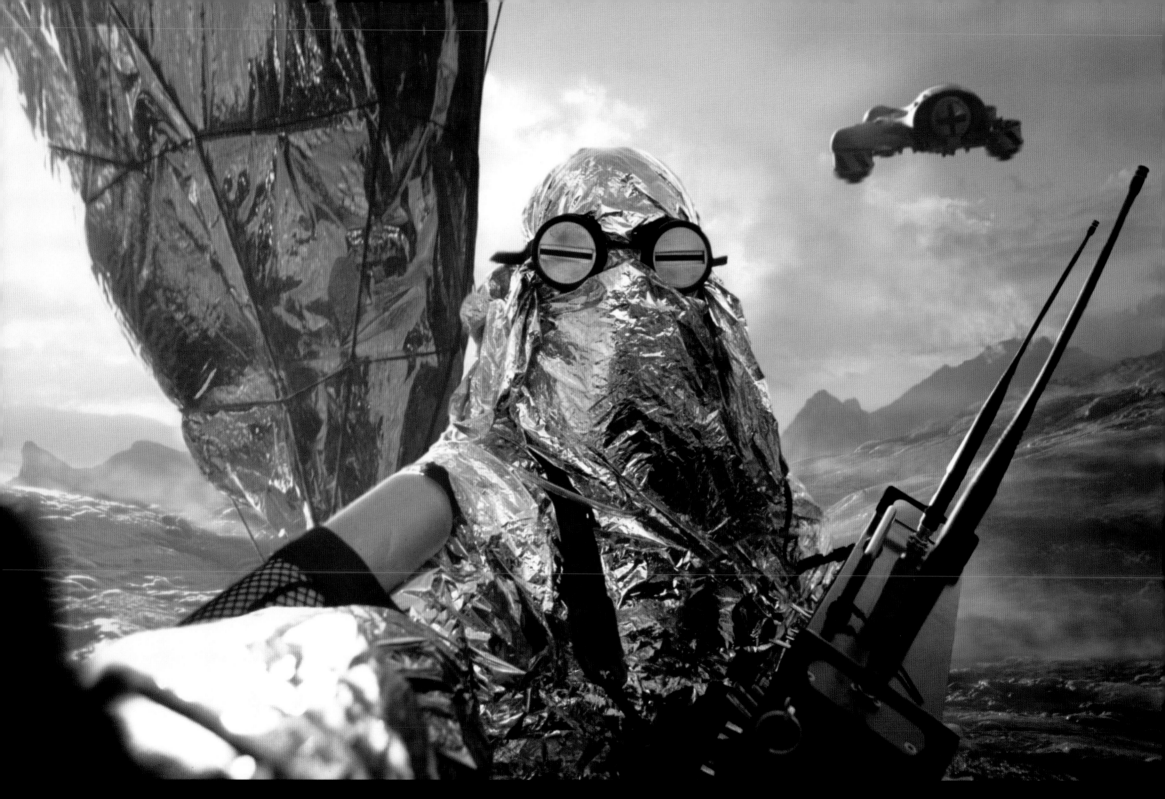

The Mylar balloon scraps offer Brooks scant protection from a toxic environment.

He wraps himself in them in an effort to stave off heat and airborne particulates. Noxious vapors necessitate supplied oxygen almost constantly. Brooks also salvages a tank of compressed helium and fashions a small balloon to assist in the transport of about 25 kilos of supplies and instrumentation. Seen here holding the ROC 2 controls, Brooks pauses for a self-portrait with the remote camera hovering in the background.

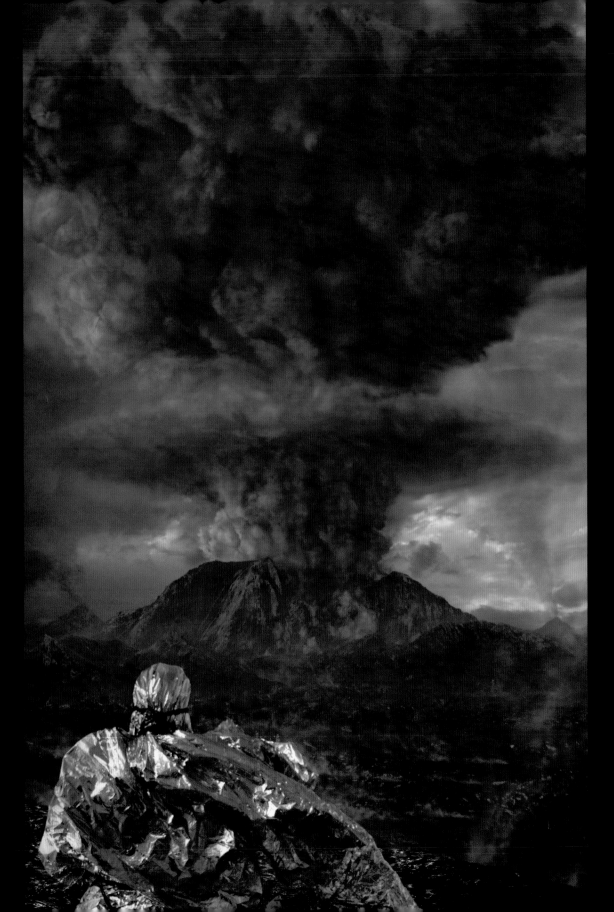

"The eruption that engulfed my craft was merely a hiccup compared to the _plinian eruption_ I have been watching for the last several hours.

The mountainside that was my home for seven months has been wiped away under a pyroclastic flow of ash and lava...X-ey must be dead...this is a volatile world, and my only chance for survival is to stay a step ahead of the elements. So far, I've been lucky, but I can't forget that rescue is a long way off."

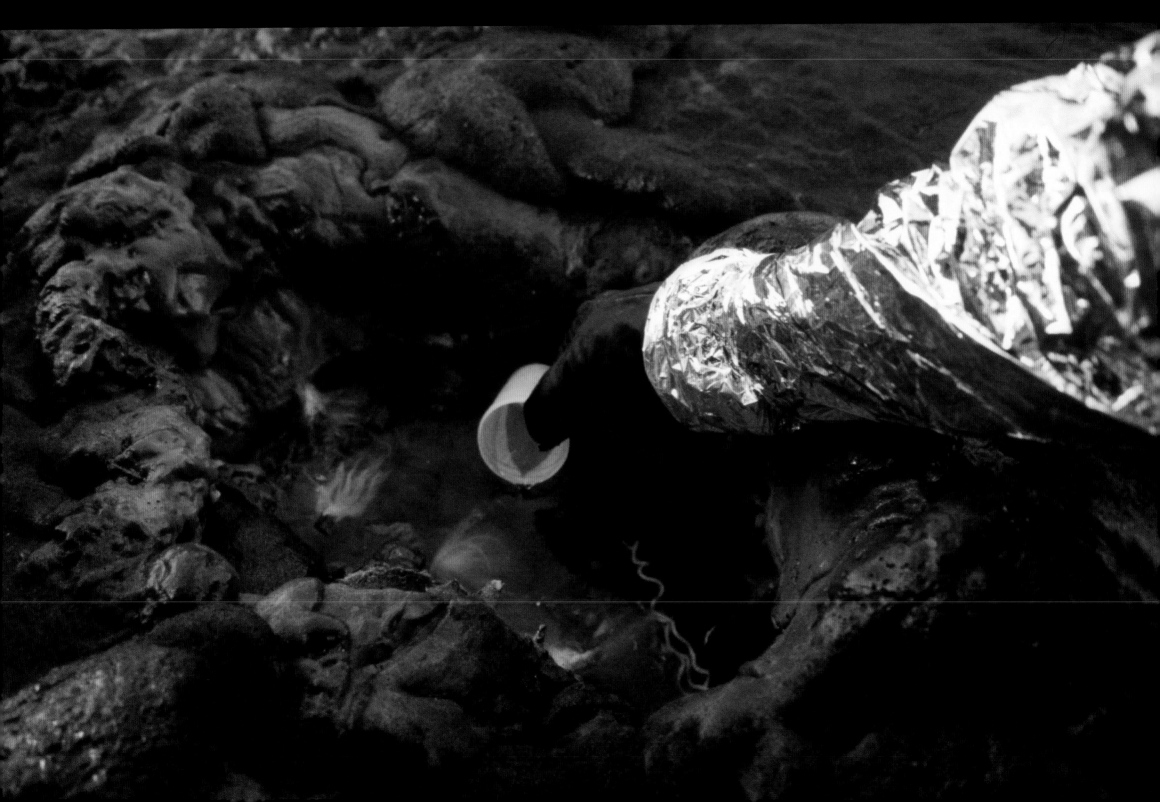

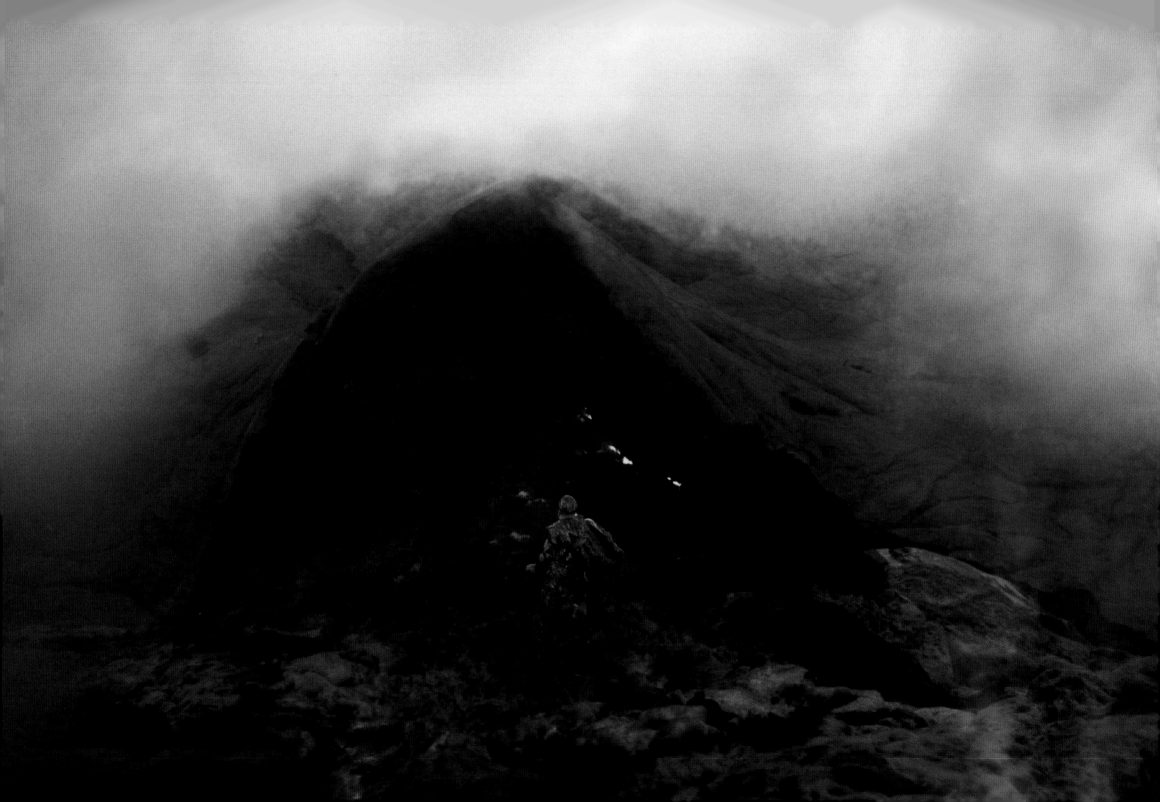

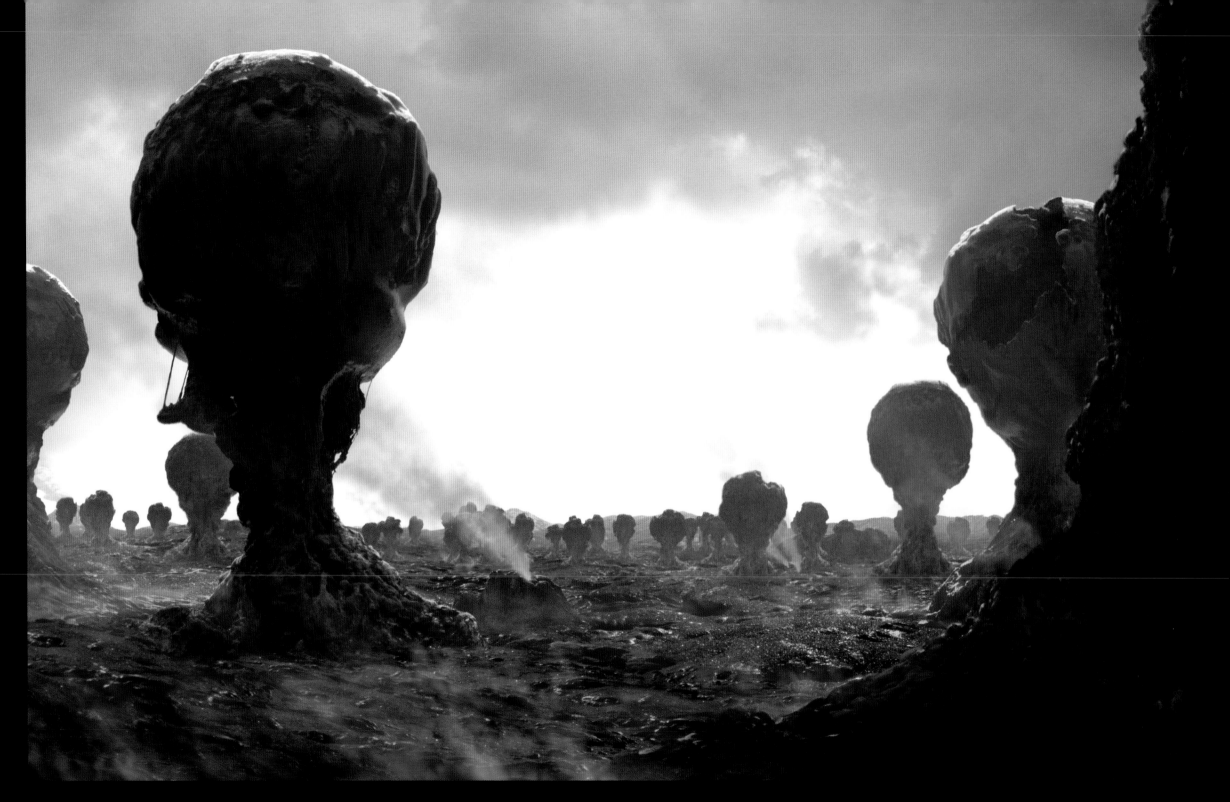

*"Strange geologic anomaly...
the long shadows I saw earlier from
high altitude...molten lava fills
with gases and erupts as a bubble,*

*High winds flash-cool the lava, leaving delicate glass
bulbs, some 10 meters high. Every few seconds one would
spontaneously shatter or break off at its stem creating the
unnerving sound of a giant breaking dishes."*

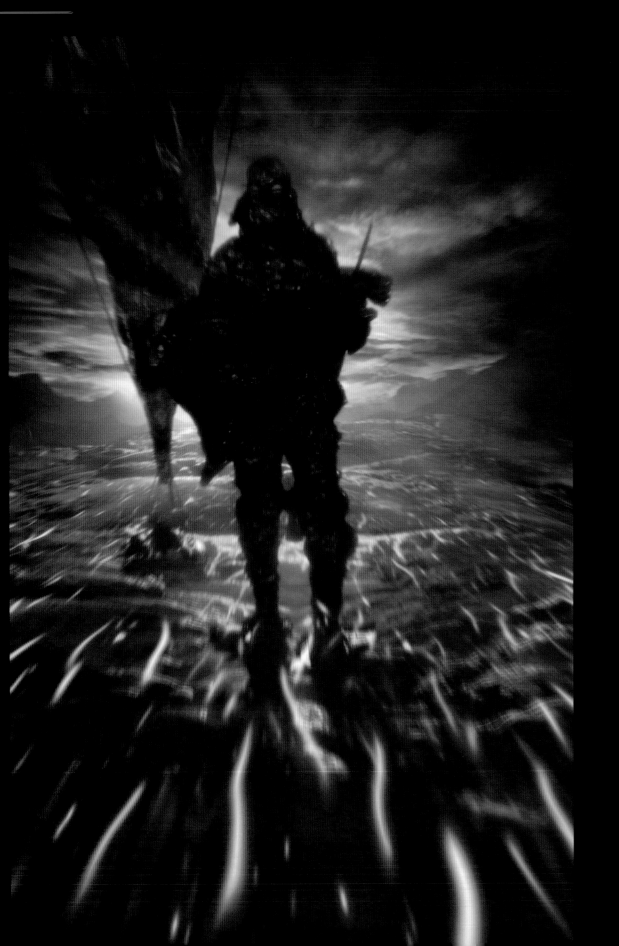

A lonely figure against an alien sky,
Brooks walks each day until darkness falls.

Continuing at night is too dangerous, as shown by this sudden burst of windblown embers, which forces him to make camp at higher ground. Although close to the jungle biome, he knows there is one more obstacle he has to cross to get there.

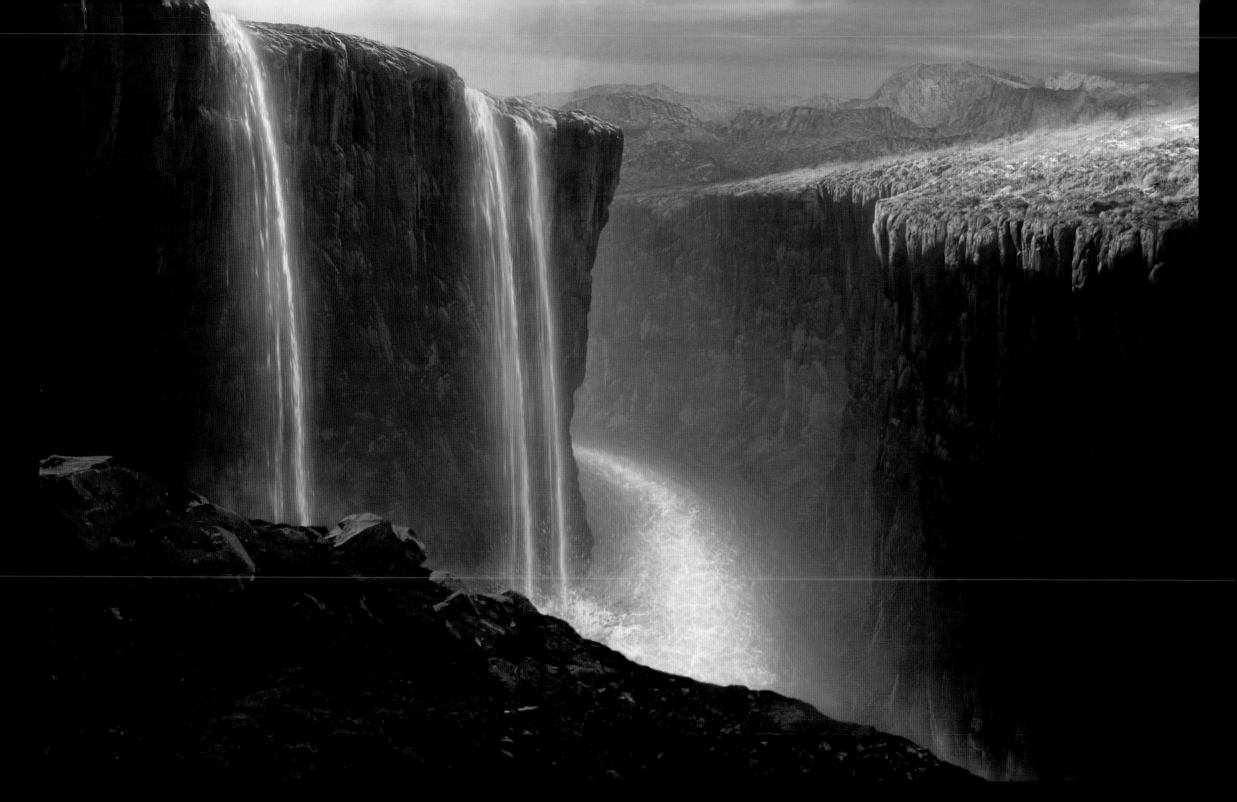

The river of fire that separates the charred geothermic region of the planet from the jungle biome seems to be an insurmountable obstacle.

But this very obstacle may be what allowed the jungle to take hold in the first place. The chasm provides a firebreak from the ever surging lava that engulfs most of the planet. Brooks' crossing is a testament to the tenacity of the human will.

"Seeing no natural bridge, I camped in a safe spot on the rim for two days, taking note of the shifting wind patterns. For about 45 minutes just

before dawn each day the wind blew strong from the Great Lava Basin toward the jungle. I stripped myself of all the salvaged gear and tied myself to the balloon. Since I weigh 81 kilos, I knew that at best I'd be in a controlled fall. I felt a bit of an updraft from the heat of the lava river below. I wish I could say I did calculations based on lift, wind speed, and trajectory but I didn't. I just jumped."

High above hell—Brooks'
dangling feet appear
in this image he took
with his handheld camera.

His daring leap across the gorge comes at a price. Although heat from the lava river provides an updraft, it also singes the Mylar balloon, causing helium leakage. ROC 2, which gives the forward momentum, is not built to carry a load and uses the last of its fuel cells. Unable to keep itself aloft, it plummets into the lava below. Brooks'

trajectory falls short of the canyon's far side and slams him into the cliff wall some 40 meters down. In intense heat, he makes the difficult climb up the sheer rock face to the jungle above.

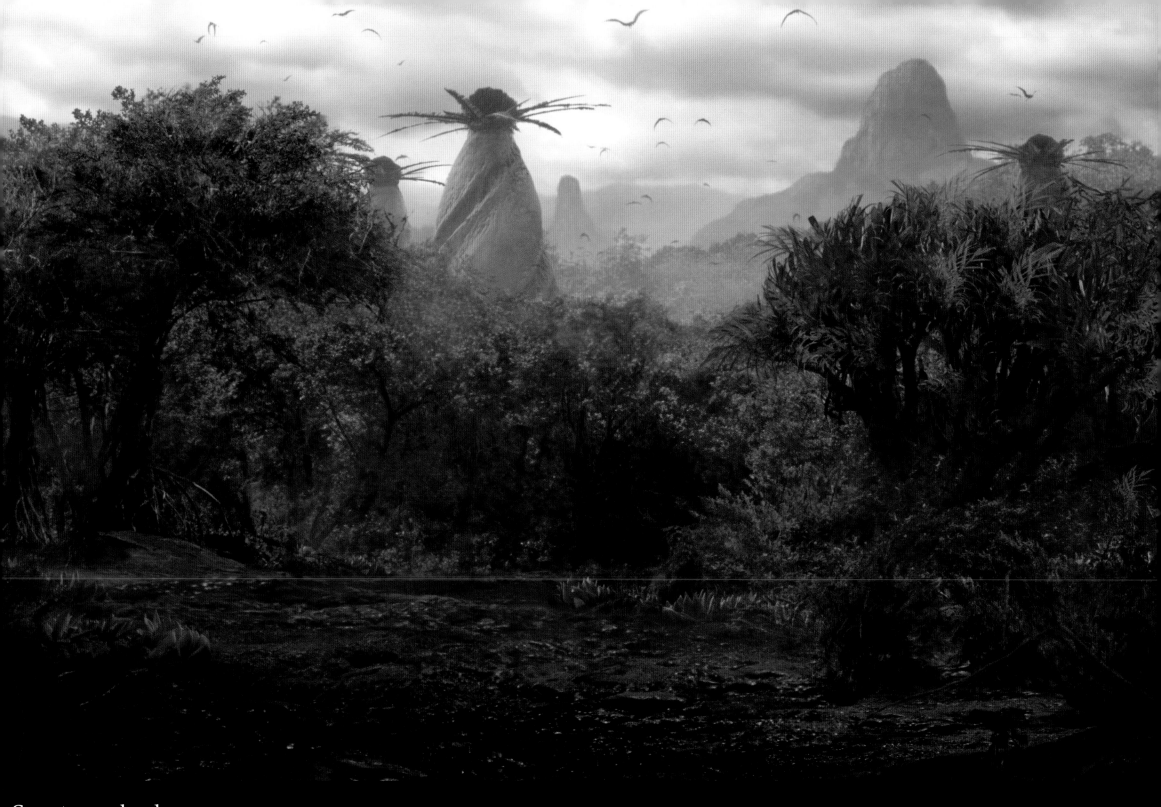

Sanctuary beckons Brooks,
who is now stripped of all
technology except for his handheld
camera and voice transmitter.

While the jungle provides him with a food source, it also
exposes him to a greater concentration of life-forms.
Many of those, it is assumed, are deadly. Despite the risks,
Brooks continues to document his journey as he pushes
deeper into the heart of this alien world.

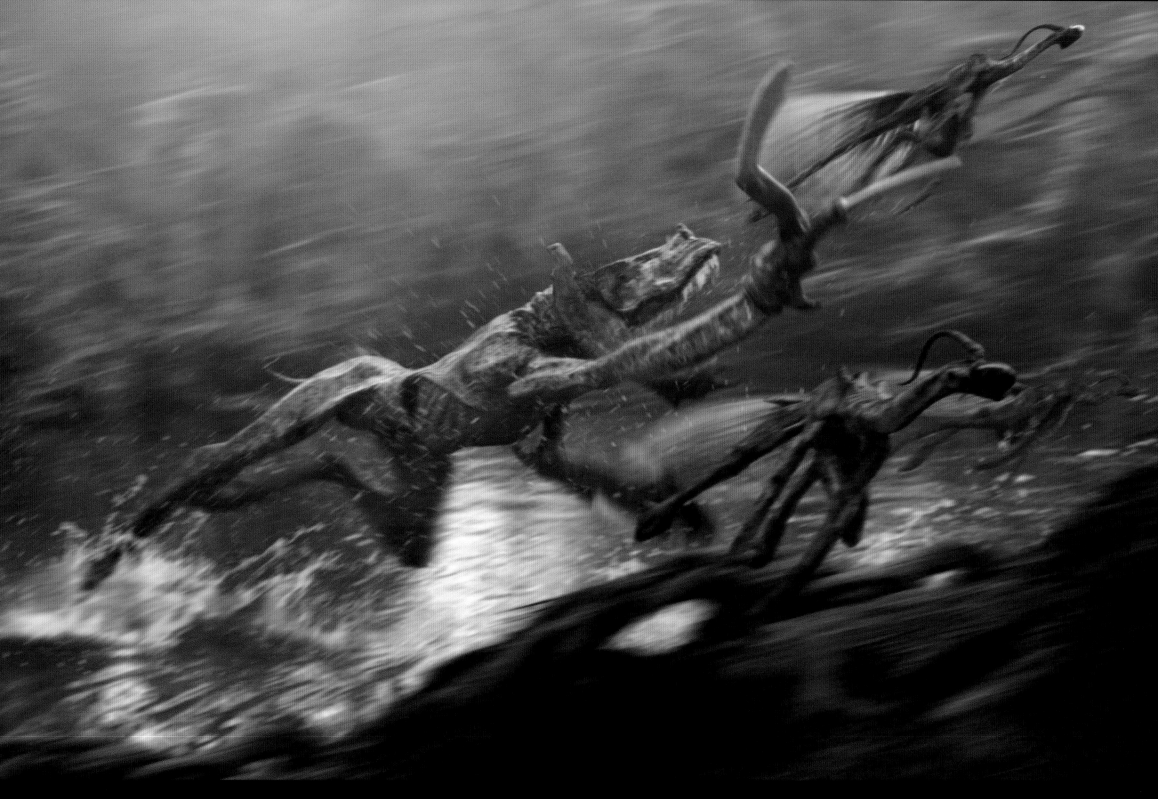

"...while this jungle biome provides me with water and an abundant food supply, danger lurks all around me.

I'm beginning to get homesick for the desolate tranquility of my mountain encampment. Here, the sheer numbers of life-forms increases competition, which has created incredibly lethal hunters. The hunted have evolved in response, developing deadly defenses that I must constantly be wary of."

This predator lurks in the river's shallow bed until it bursts into action and pursuits a flock of small fantailed creatures. Brooks estimates its phenomenal speed at about 120 mph. After bagging one of its prey, the creature lounges in the water, steam rising off its skin as it's overheated body cools. Side openings allow air to cool its bloodstream and internals.

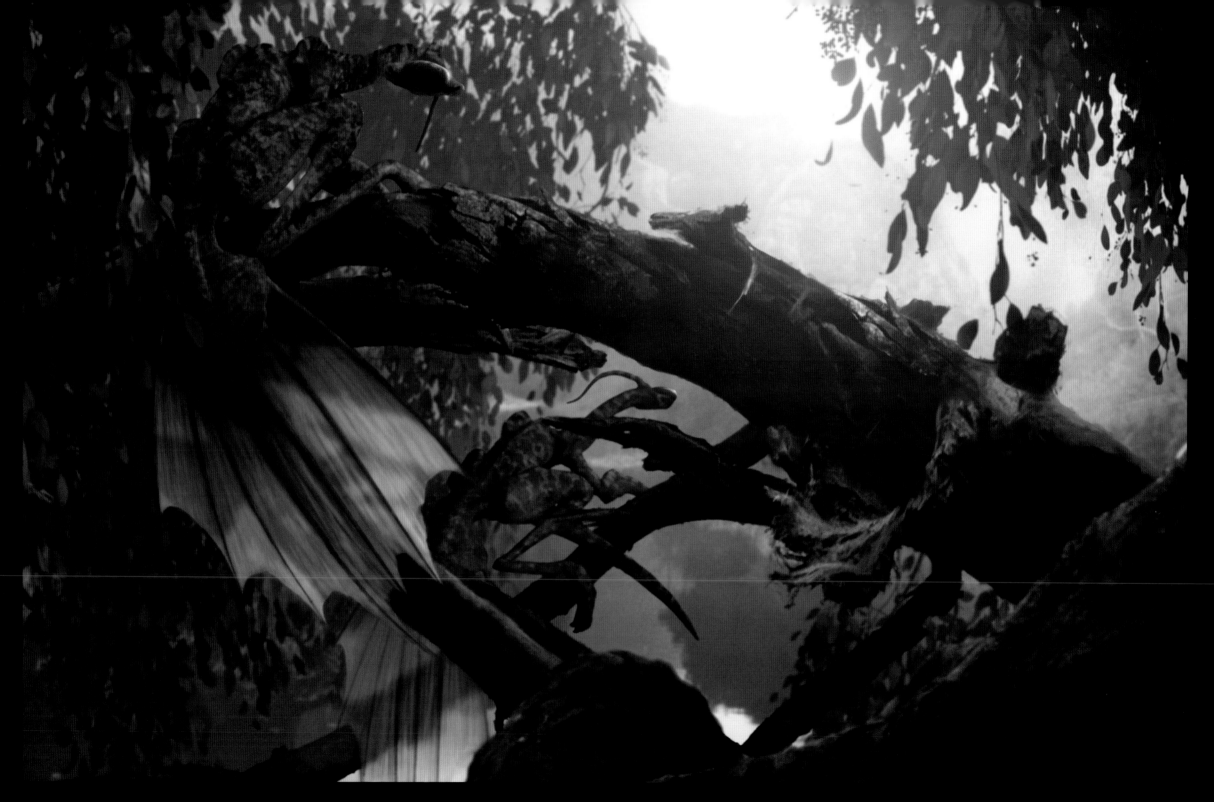

Seeking refuge in the treetops, these survivors nurse their rattled nerves.

As a defense measure, their broad tails allow them to fly

tail membranes flush with a fluorescent pigment. As the flock scatters in front of a predator, the chaotic pattern confuses and distracts, increasing the chance of escape. This group's tail membranes return to a dull tone within seconds of their brush with death.

Watching from within a wall of foliage, something enormous spies on an unaware Brooks.

"I realized that what I thought was the sound of the wind in the trees was actually the breathing of a gigantic creature. I gathered no information regarding this life-form, other than this image of a cluster of eyes imbedded in a wall of flesh. I didn't think it was wise to remain in the area for too long..."

Shortly after this image was taken, Brooks' voice transmitter ceases to function, possibly due to water contamination. He is now a mute observer, and the following descriptions of this strange world are scientists' estimations.

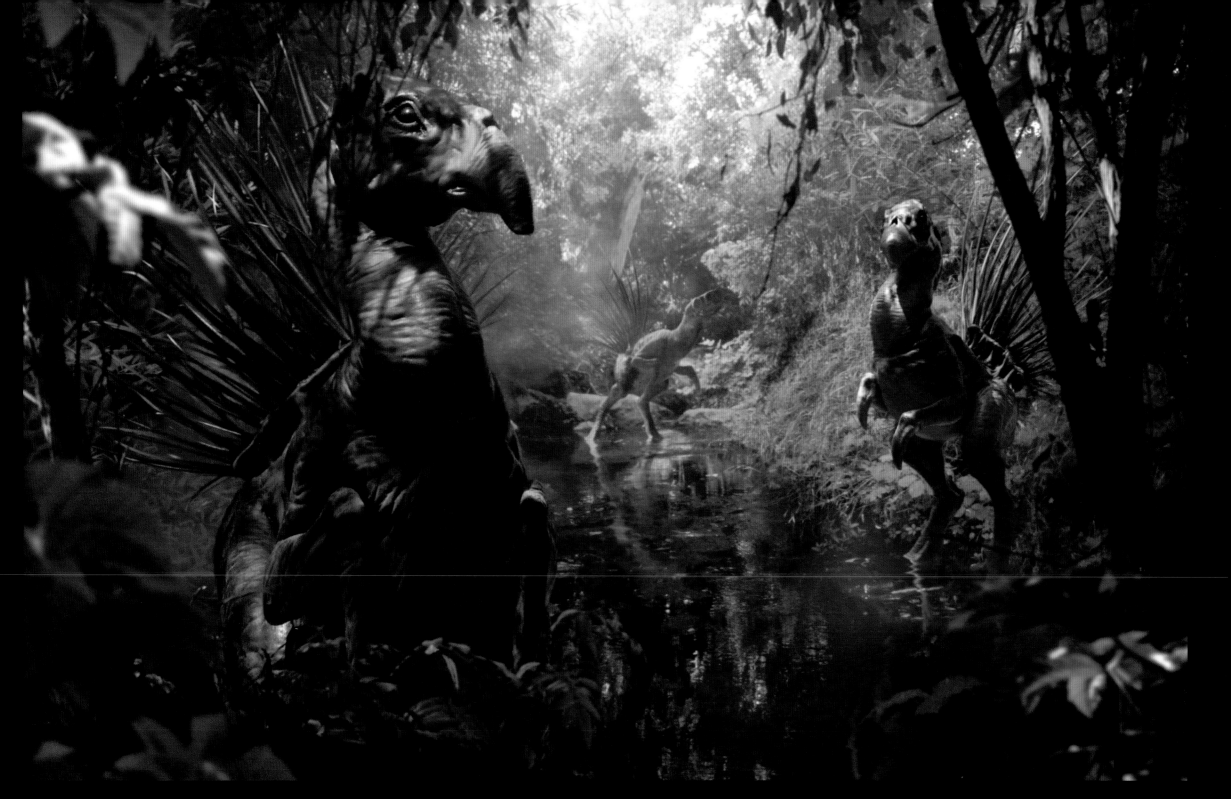

A seeming paradise hides many a **lurking predator** from the watchful eyes of *Nobilis Periculosis*

This herbivore has developed an impressive defense to protect it from rear attacks. The array of quills on its hindquarters are rooted to a muscle pad that when flexed gives the bundle of rapier spines 100 degrees of movement in all directions. When the herd is alarmed, droplets of neurotoxin secrete from the tips of the hollow quills and emit an odor that act as a warning to would-be attackers. If the attack comes, the *Nobili* assume a circular defense-formation by facing inward with the young in the center. The formidable wall of poisonous spines deters all but the most foolhardy of enemies. Some predators, however, have evolved interesting ways of breeching *Nobilis' defenses.

One **careless step**
is all it takes to pick up
an unwanted passenger.

The decomposing carcass of an amorphous life-form *(Ingratus Vector)* carries within it the larva of its offspring, which feeds on the remains of its parent until something better comes along. The unsuspecting adult *Nobilis* doesn't

feel the tiny parasite as it crawls upward, drawn toward its host's respiration. The sticky mucous aids in adhesion and also contains a topical anesthetic, which numbs the host's skin and makes the sluglike larva undetectable.

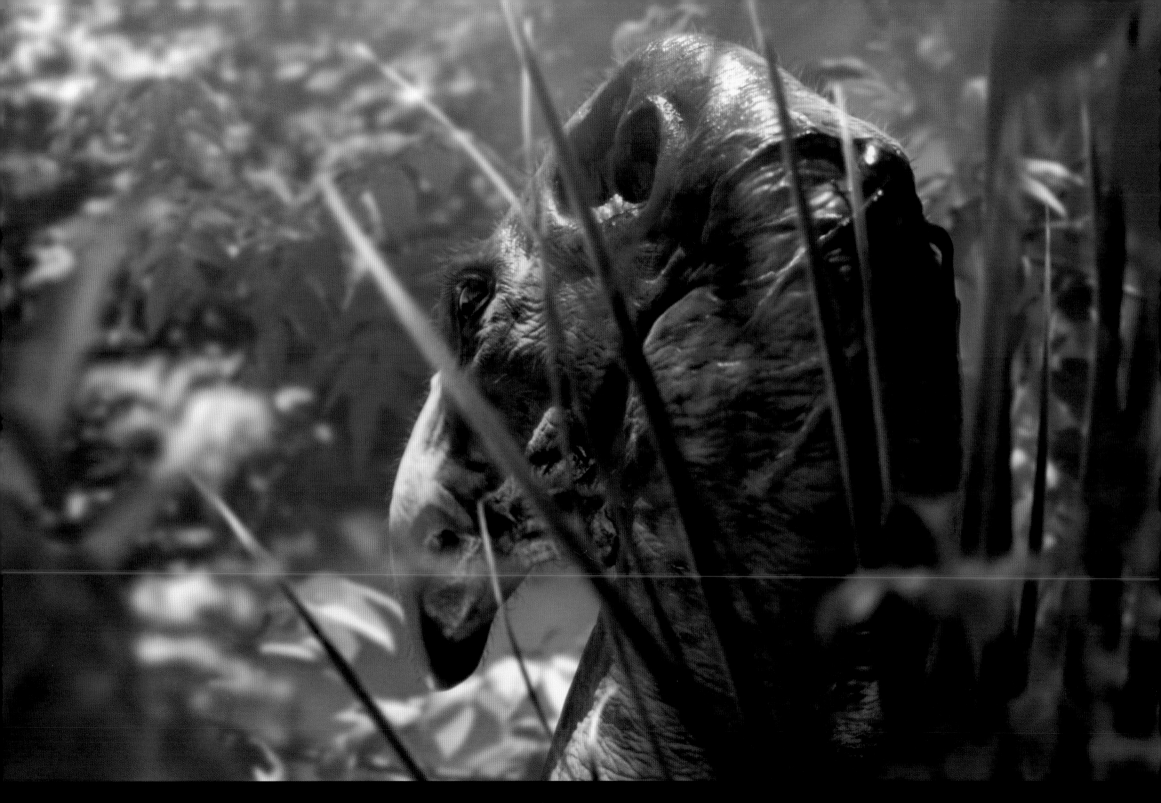

No defense from *Nobilis'*
poison quills can dislodge
the parasite growing at the

After a grueling trek up the host's body, its tendrils bur-
row under the skin, attaching to the victim's nervous sys-

rapid growth. The battle for control of the host's body
results in several days of odd behavior, after which the

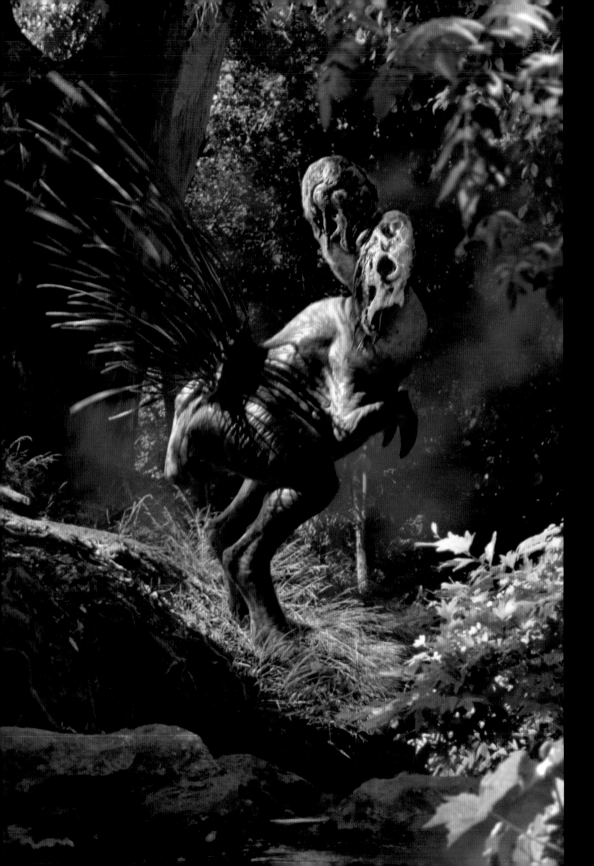

The **inevitable outcome** of the struggle is seen several weeks later, when Brooks finds the creature basking in Proxima's warm rays.

The parasite completely cut off circulation to the host's head, which hangs lifeless and rotting. No predators come near, despite the blind stumbling of this bizarre amalgam of life-forms. It is left alone to its

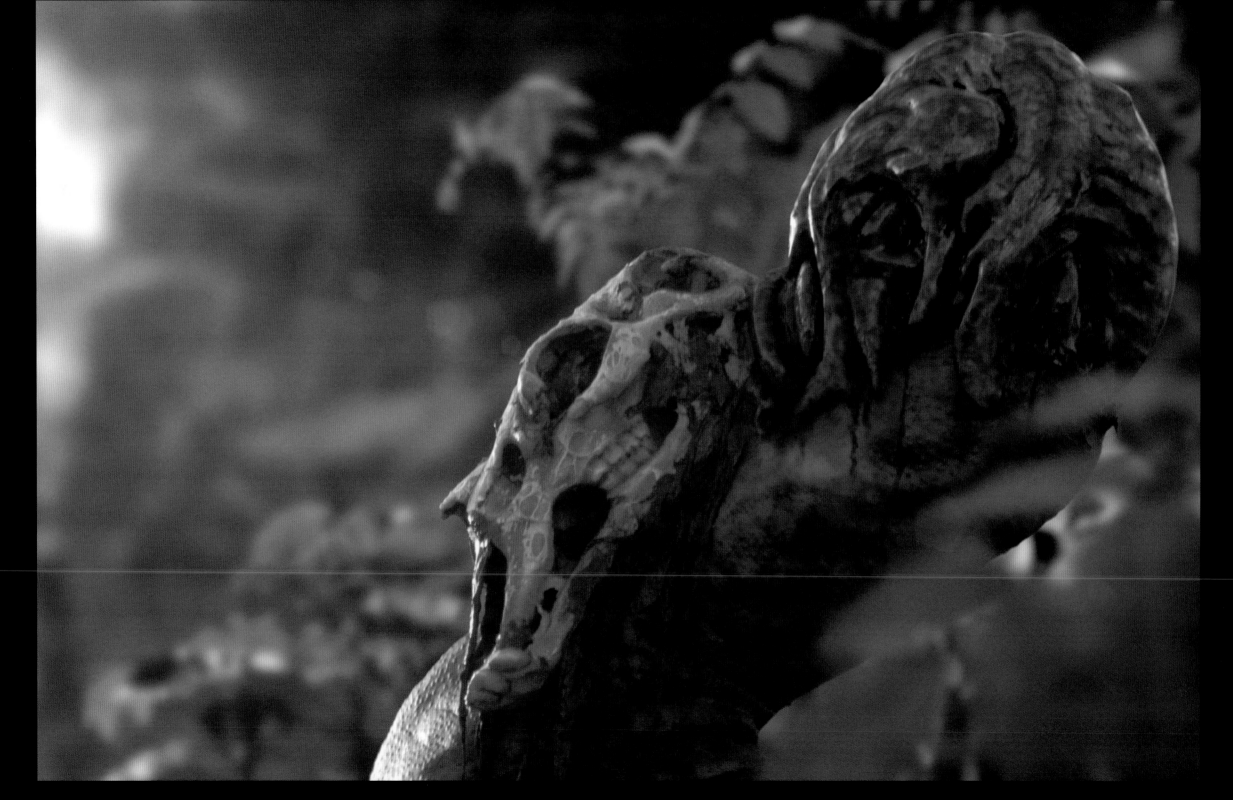

On its last legs,
the parasite uses up most of what the host can provide.

Although the host's heart, lungs, and circulatory system still function, it cannot eat, and the body weakens until it collapses, having been driven into the ground. If the parasite has not found a mate by this point, its only remaining chance is to adhere itself to a new host, perhaps a curious passerby. If that happens, it can resume its quest to procreate and begin the cycle anew.

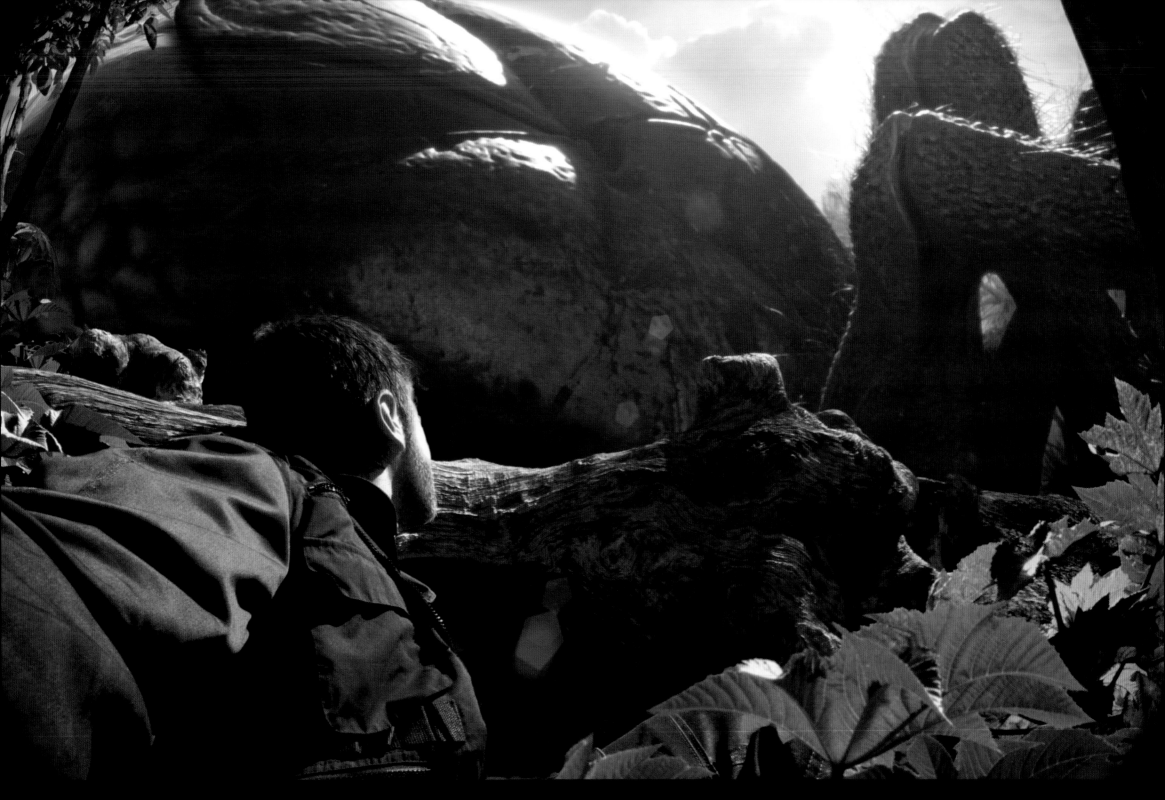

In the shadow of the behemoth, Brooks takes this **self-portrait** from behind the relative safety of a fallen tree.

Mission Control is concerned when Brooks stops including himself in his photos. The self-portraits are the only way to evaluate his health status.

From out of the depths, this
water-dwelling insectoid
drags its egg sac behind it, until tearing
it open on broken tree stumps.

The rivers and lakes of Proxima 4 are water-filled fissures, and some have been sounded at 1,800 meters deep—nearly one-and-a-half times deeper than Norway's glacial fjords. The river's water source is unknown; rainfall couldn't possibly fill these deep chasms, and the Southern Sea is 2,500 kilometers away. Also, the geothermic character of this world makes an underground ocean unlikely. This planet does not give up its secrets easily.

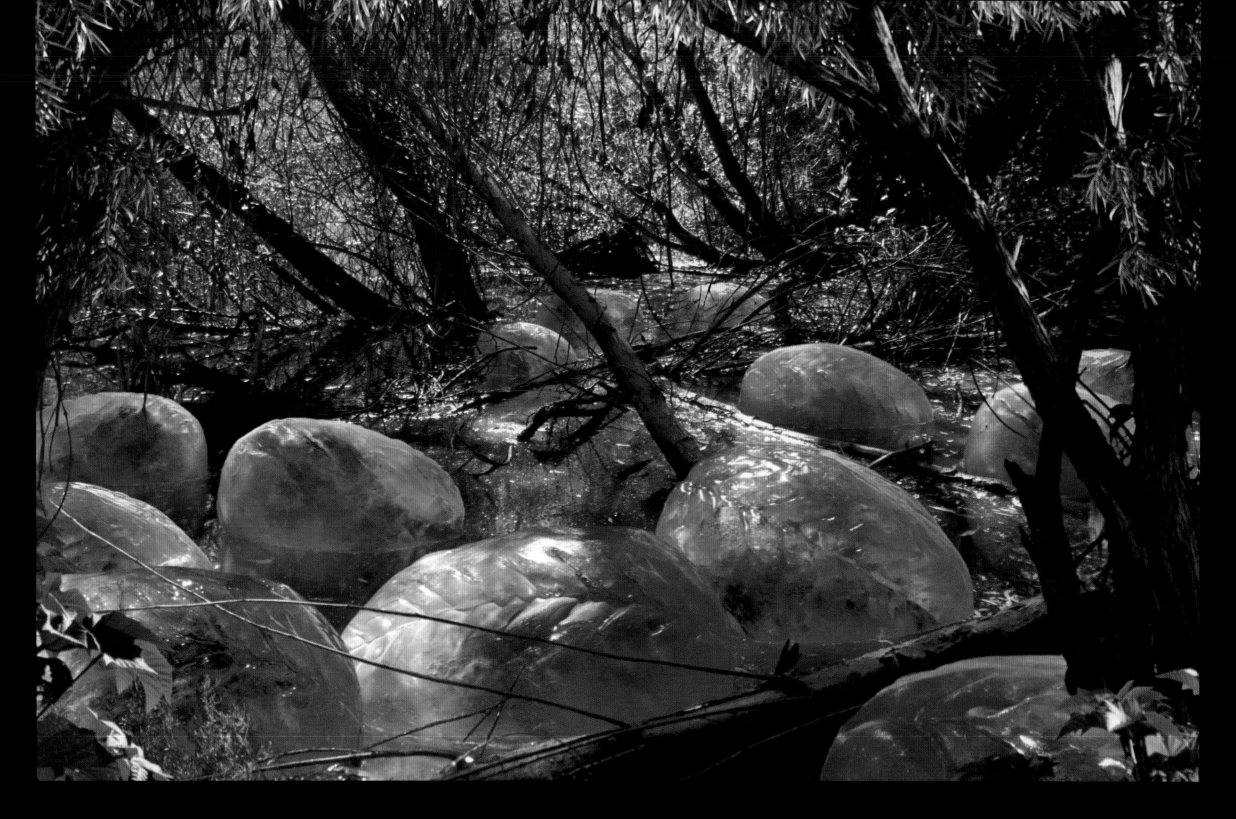

Bobbing in a pond of
proteinaceous fluid, the eggs
incubate in dappled sunlight.

The huge volume of fluid released by the torn egg sac creates a minor flood that drives other life-forms out of the area. Later, predators and scavengers return to the newly formed marsh to feed on the unhatched eggs, reducing their numbers by about 60 percent.

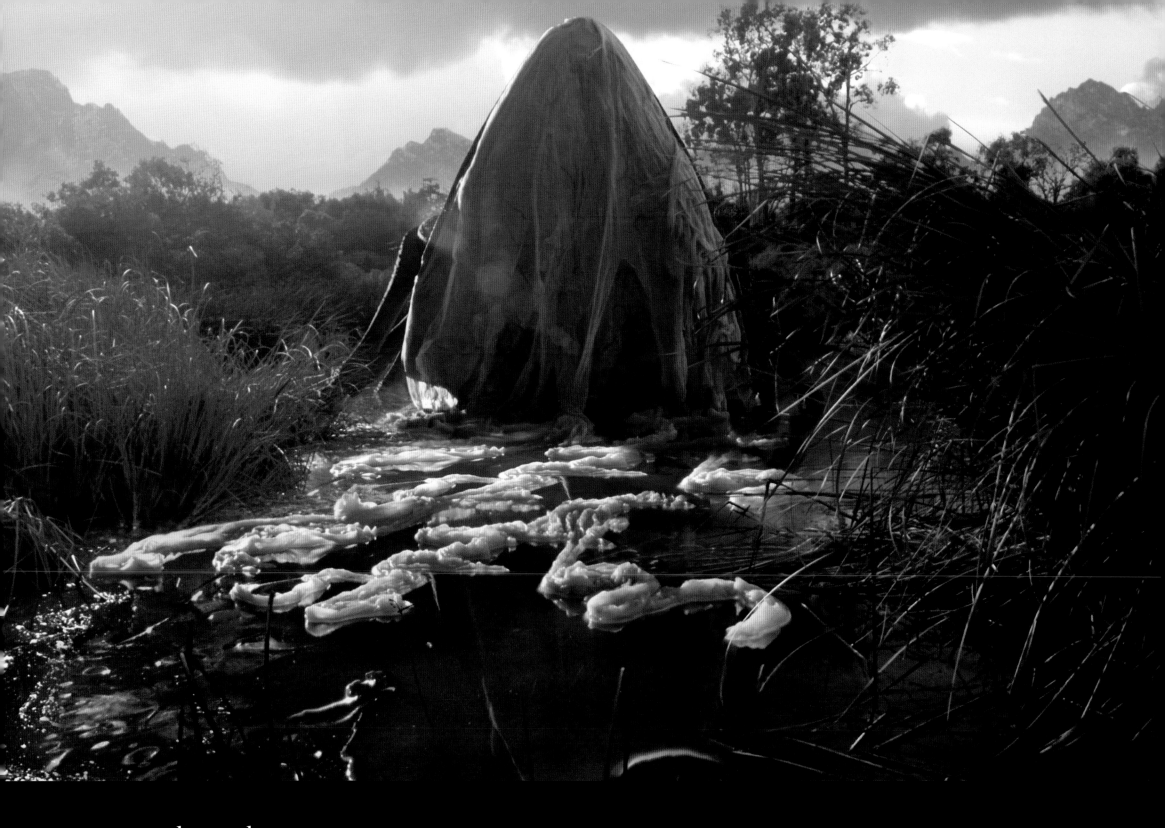

Trailing a **tattered membrane** behind her, the new mother returns to her watery world. Her parental obligations are finished, and she leaves her land-born offspring to fend for themselves. Eventually they too will return to the water where they will mature, growing to the proportions of their enormous parent.

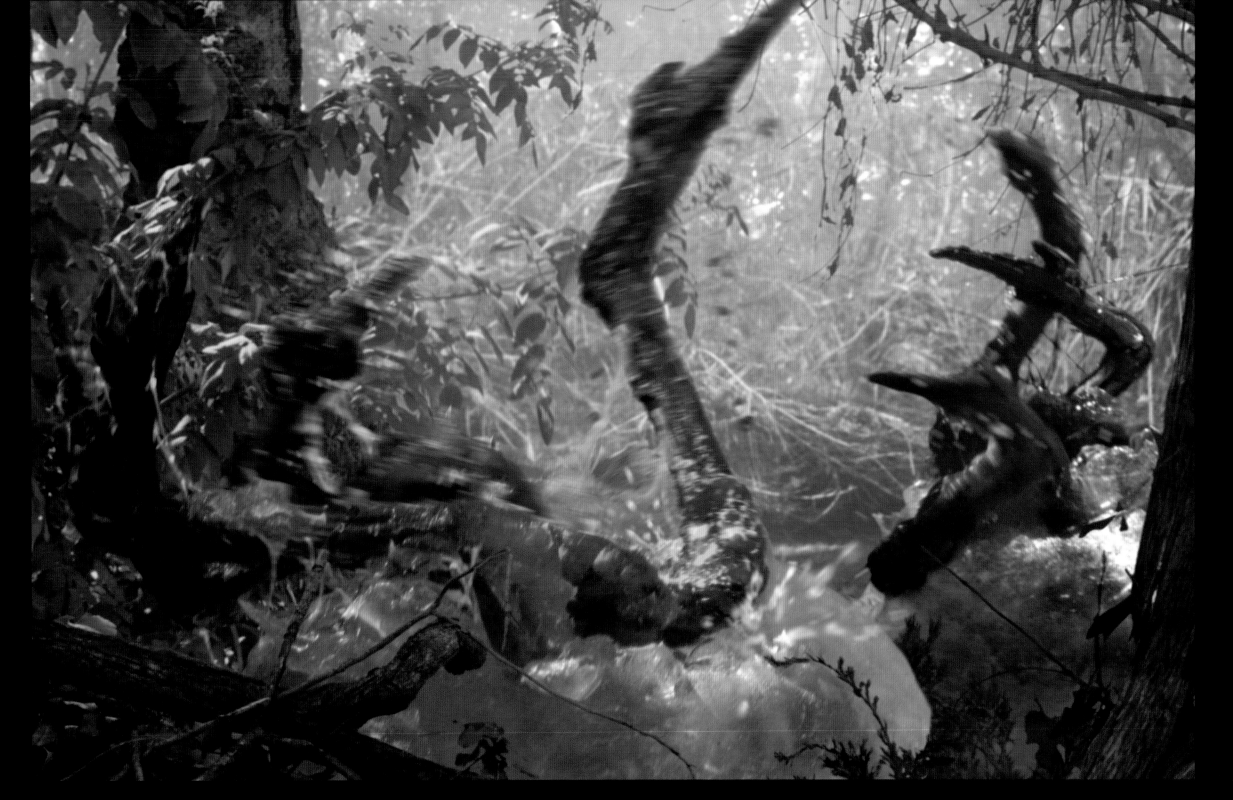

In an eruption of **flailing limbs,** the newborns surrounding Brooks begin clawing their way out of their eggs.

Infestus Liberi's synchronized hatching may be a protective mechanism; there is safety in numbers, and this type of hatching would make it difficult for predators to pick off lone stragglers. The hatchlings stay in the marsh until nightfall when they then break into hunting groups and disperse into the undergrowth.

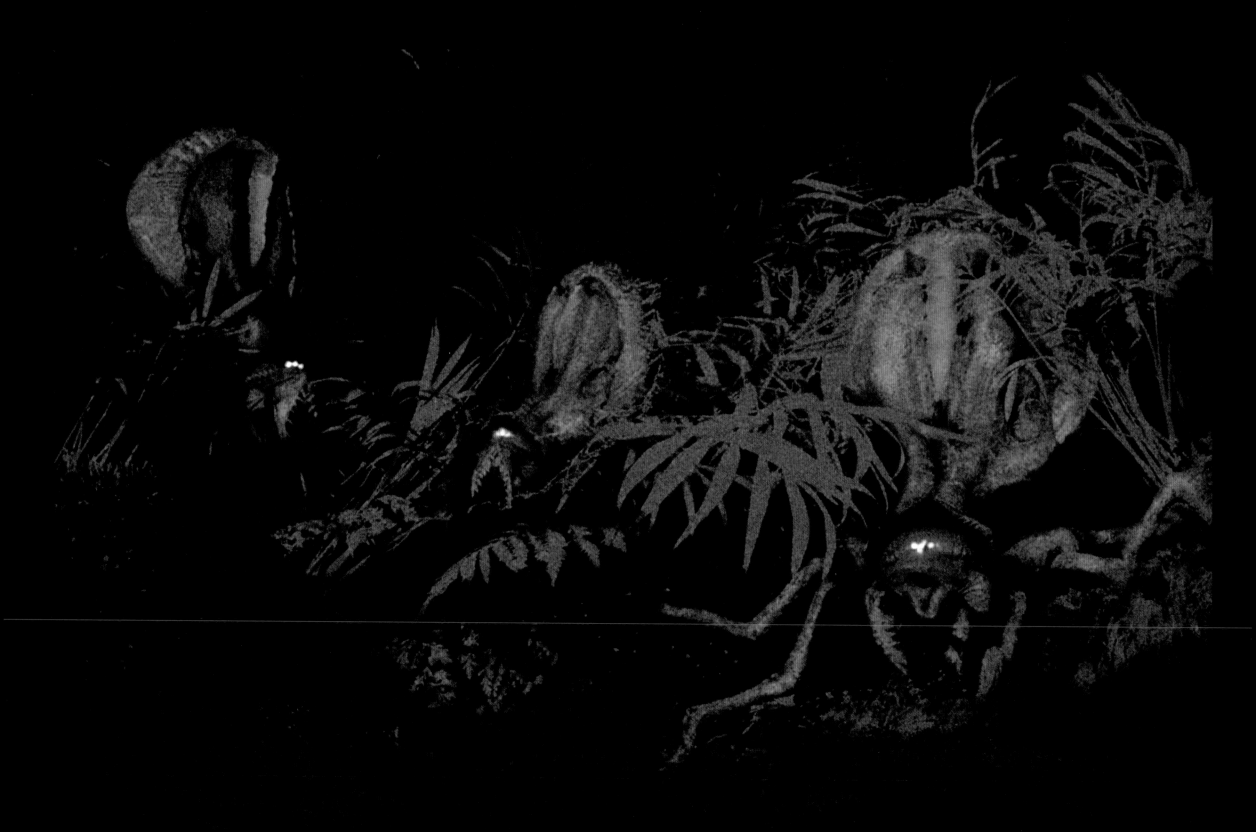

Darkness unveiled by the probing eye of the infrared camera shows a group of hatchlings hunting at night.

Ravenously hungry, they eat almost anything. Brooks observes them pack-hunting other creatures, eating carrion, and stripping foliage down to the stalk. (One unusual characteristic of these water-breathing insectoids is the sac of liquid they carry on their backs. This allows them to survive in a dry environment in the same way that air tanks allow a diver to survive underwater.) Brooks decides to continue his travels...in the opposite direction of these voracious hunters.

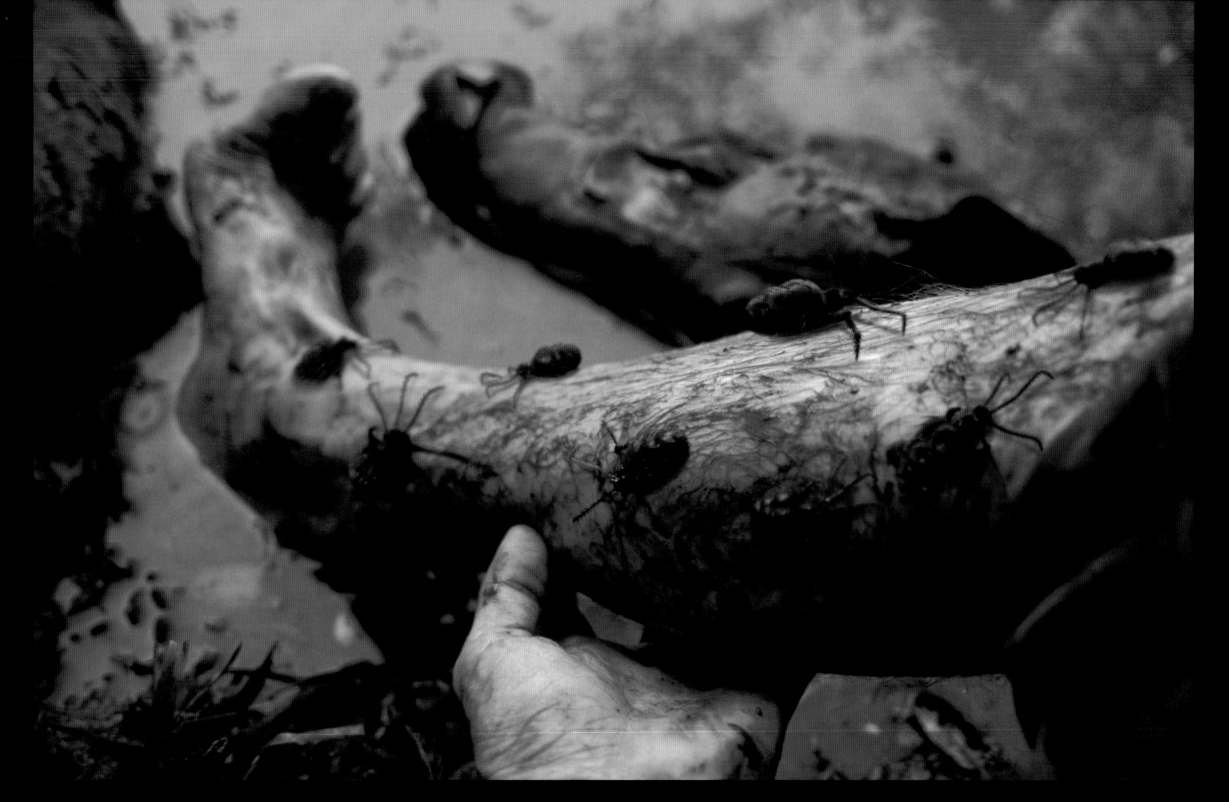

Predators great and small seem to inhabit every square inch of this highly competitive ecosystem.

Brooks acquires nasty parasites while wading across a stream. As grisly as this image is, the shots of the removal process are even worse and are not shown in this collection. A growing number of Worlds team members lobby to awaken Brooks' wife from biosuspension and to inform her of her husband's predicament. Others argue that as long as he is alive there is hope for rescue and that his family should be awakened when he returns home. With his internal nanotechnology failing, the question lingers: How much longer can Brooks survive?

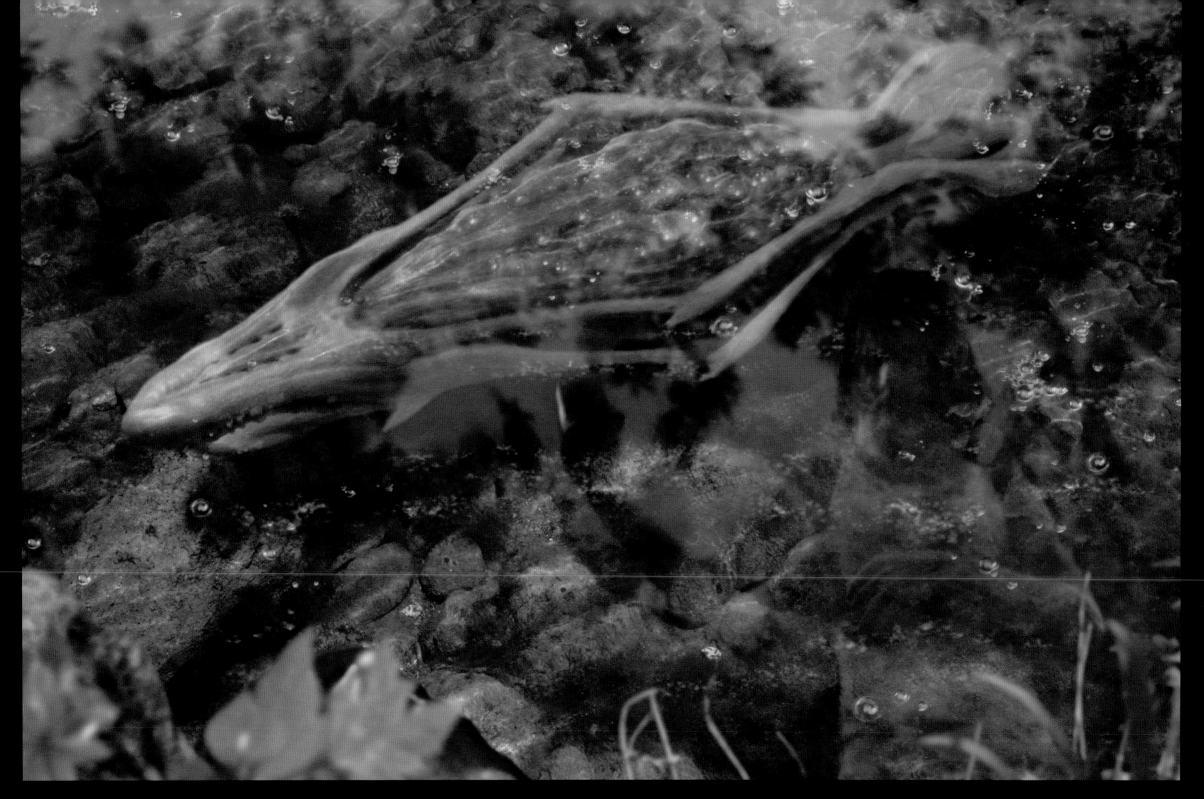

A similarity of form is evident in this **aquatic creature**, which bears a resemblance to those found in the Southern Polar Sea.

Both species have jointed appendages for propulsion, although adaptation to a shallow-water environment has triggered evolutionary features unique to this particular life-form. A flattened body allows it to stay submerged, while breathing through top-mounted nostrils minimizes body exposure. Differences between this individual and its open ocean cousin

parallel the evolution of Earth's ocean and river dolphins.

This image is the first sent by Brooks in months. Most mission members believed him dead, but their rekindled hope is dampened by the reflection in the image's lower right corner. Brooks inadvertently takes another self-portrait—one that raises great concerns back home.

The **remnants** of the man are evident in this enlarged section of the image.

His muscular frame has withered due to malnourishment, and with his internal nanotechnology inactive, his body is under attack by alien microbes. The weary look on Brooks' face suggests to many that he knew his time was drawing near. Indeed, perhaps by sending this image he wanted to soften

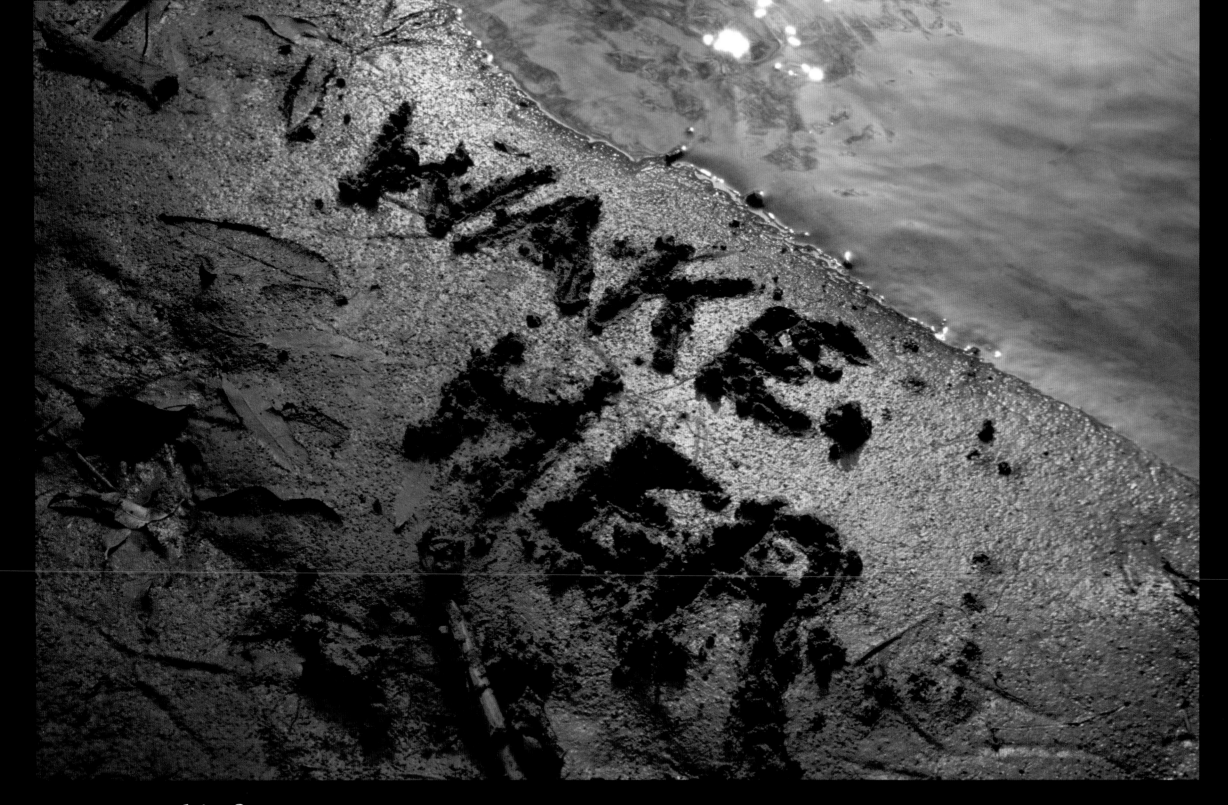

Accepting his fate, Brooks scrawls these words to Mission Control and asks them to rouse his wife from biosuspension.

His daughter is left in stasis as the remaining images stream in over the next few days.

A bold attack on this huge **ambulatory** plant
is carried out by a pack of *Infestus*.

The now adolescent offspring Brooks thought he had outrun are a presence again, on the hunt for prey
of any size. This time it is one of Proxima 4's hybrid plant-animal life-forms. *Ambuloflora*, a carnivorous
plant similar to our own pitcher plants, is essentially a hollow tube with a cluster of grabbing claws that
hold its quarry high over its "mouth." It then regurgitates its corrosive digestive acids in a shower that
dissolves its victim's body into protein slurry, which pours into its primitive stomach and is absorbed
through the chamber walls. When attacked, the plant unleashes a torrent of acids as an indiscriminate
weapon. The giant is overt...

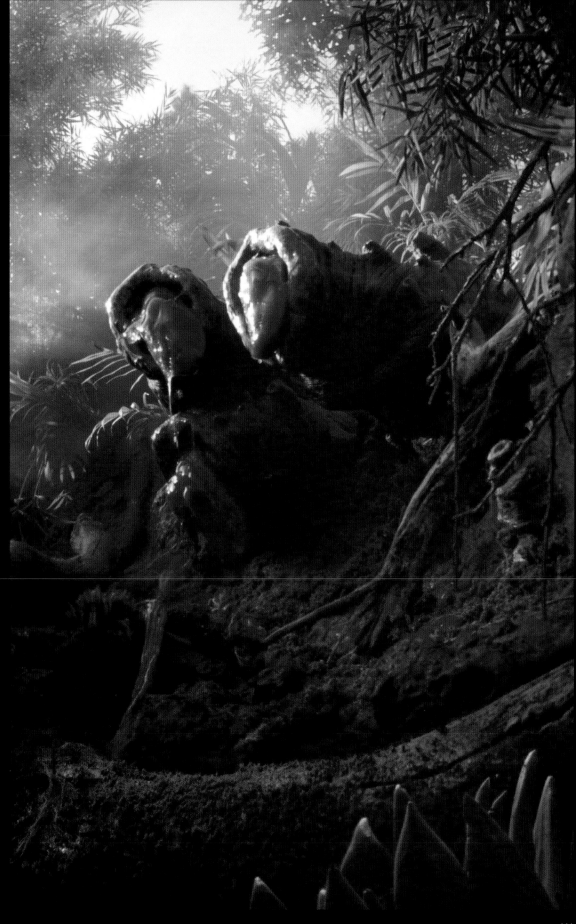

Silently, patiently, this predator's tentacles
poke out from the protective shrouds
of rock-hard carapaces,
while the insectoid awaits its next meal.

The armored sheaths are made from the extruded feces of the creature lying buried deep under the jungle floor. Brooks scans a tentacle circle of about 200 meters across, and scientists assume the main body of this enormous life-form is in the center.

After some quiet observation, the appendages ripple and stiffen. The delicate vibration of their sensitive follicles alerts them that prey is near.

The hunter becomes the hunted as the powerful tentacles burst forth to entwine *Infestus*.

The shell-cracking constrictor is victorious but pays a price. Not only do the insectoid's scrabbling legs badly lacerate the tendrils, but the rest of the pack arrives to inflict more damage, forcing the snakelike appendages to retreat deep into their underground lair. The surviving *Infesti* then feed on the remains of their fallen sibling.

Sensing a presence, an *Infestus* locks its multiple compound eyes on Brooks, who apparently stumbles upon the creatures as they feed on fresh kill. Brooks flees, hoping the ravenous killers are more interested in their fallen prey. He is wrong.

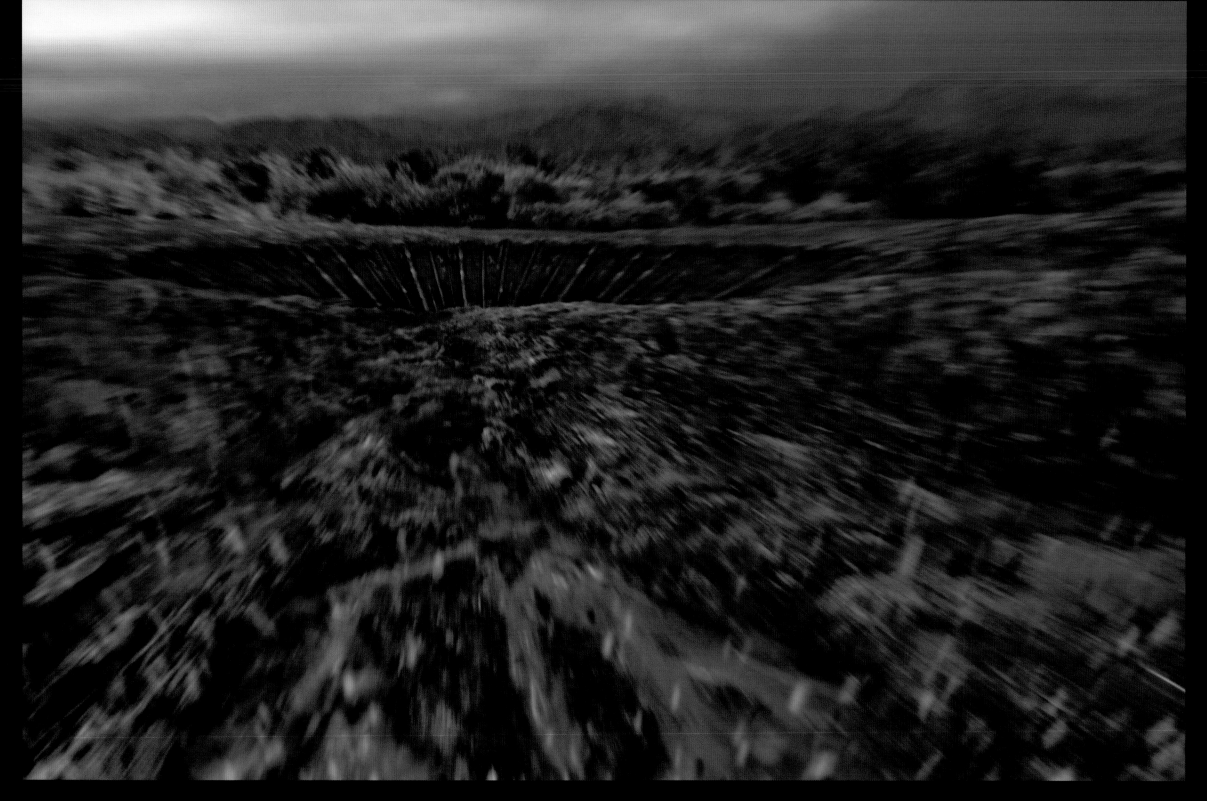

The last discovery

Brooks makes is while he runs for his life into the center of an open field.

Slogging through the knee-deep mud, he snaps this image of what appears to be an artificial structure. Water and mud seem to flow toward it, indicating that it is an intake port or drain of some nature.

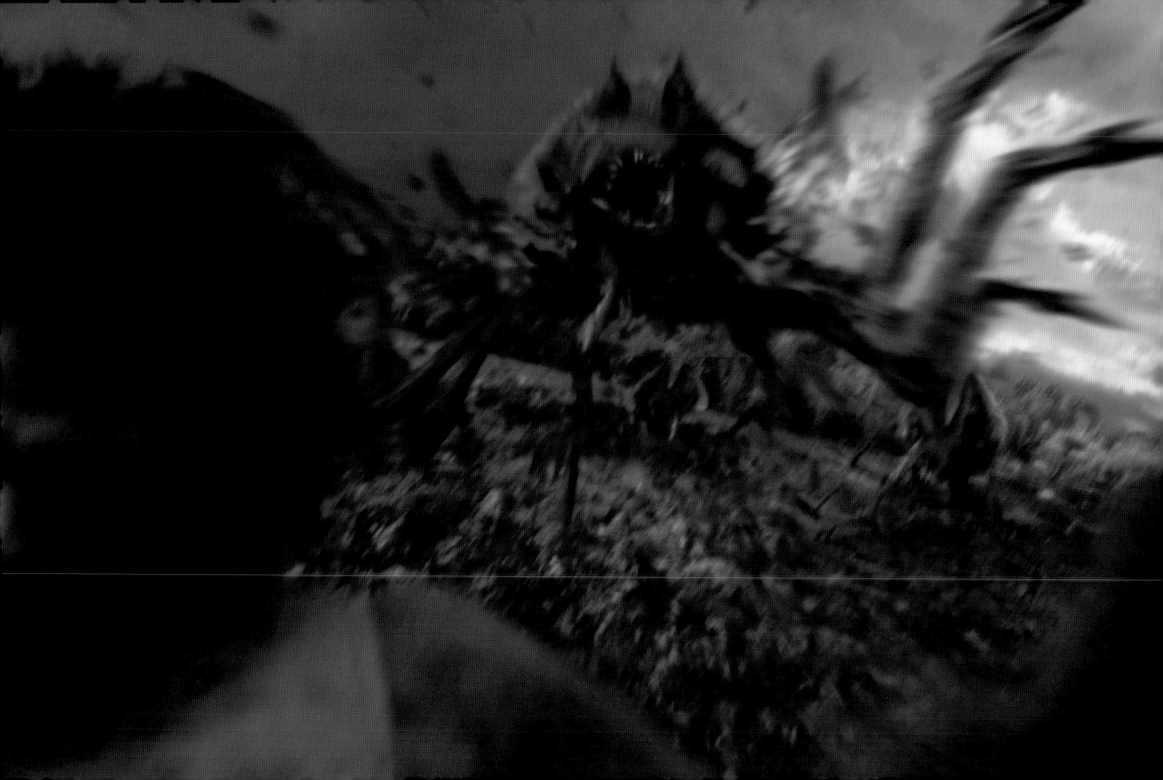

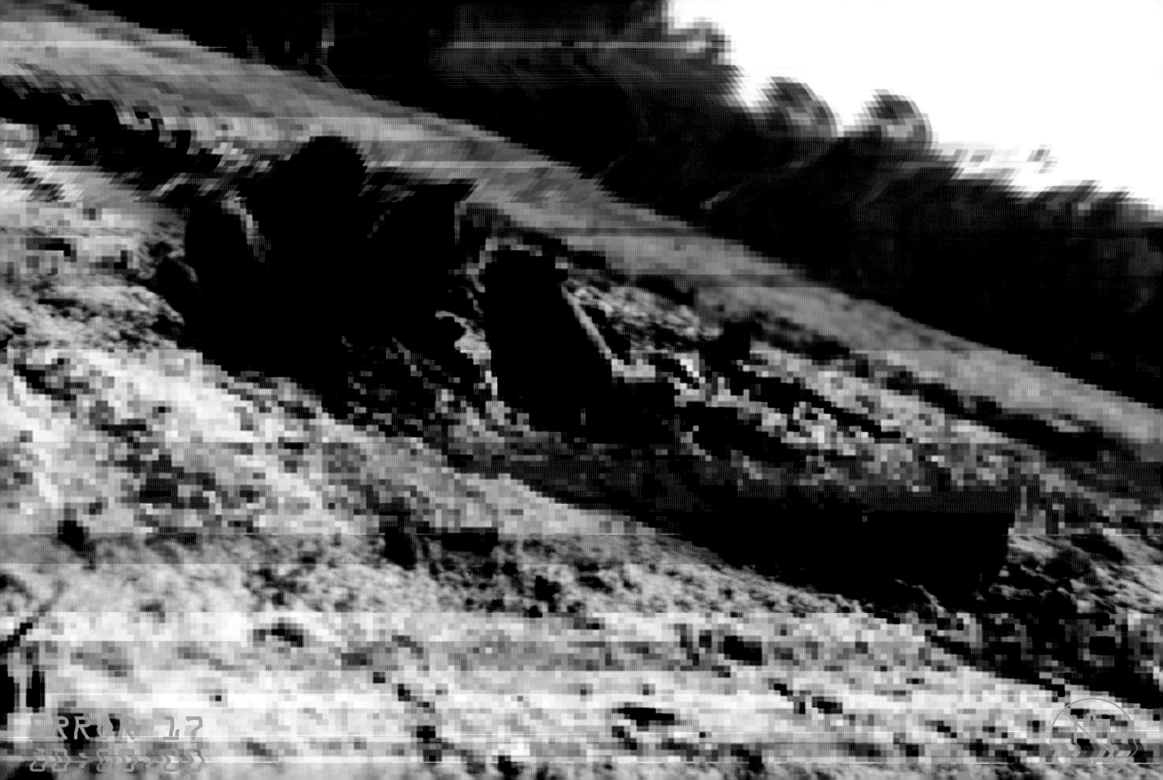

A World Revealed

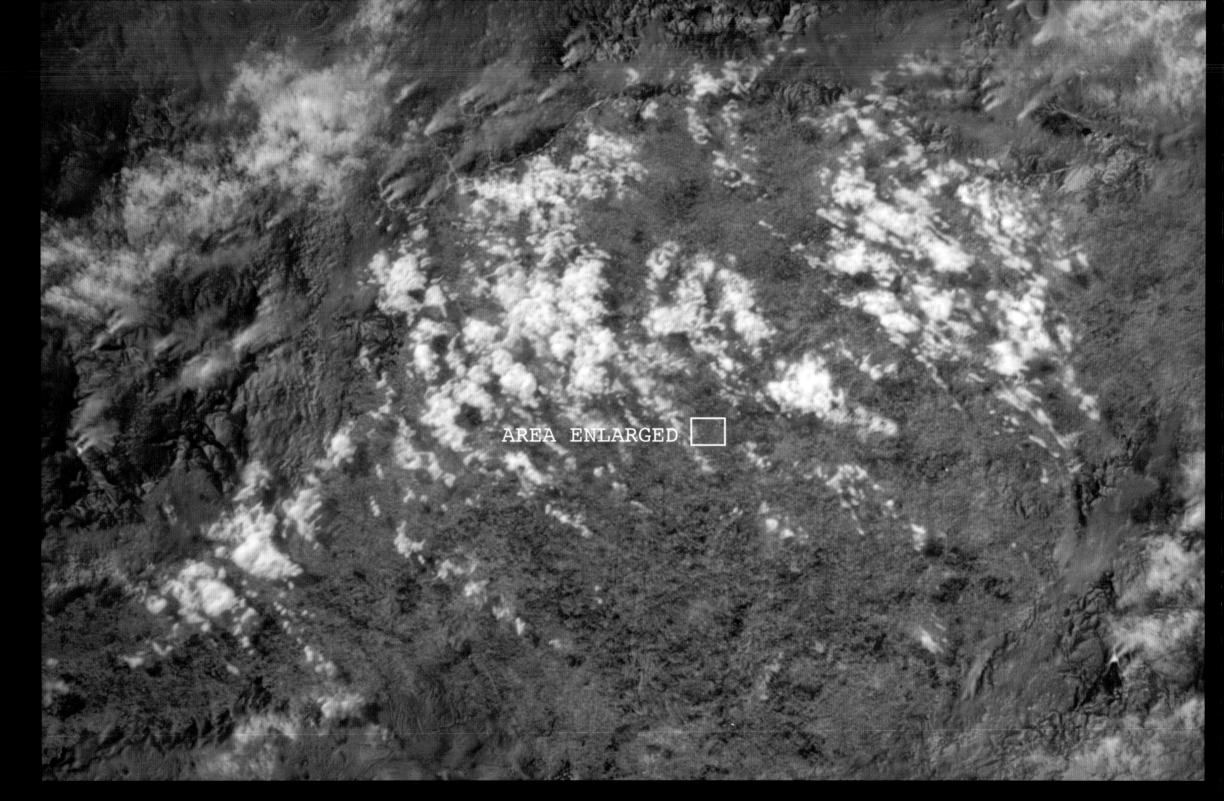

AREA ENLARGED ☐

The heart of the wilderness
is where the transmissions

Referring back to the earlier high-altitude shots of the jun-
gle biome, scientists begin to examine the area where he
discovered the mysterious intake port.

AREA ENLARGED

Closing in on the mystery, scientists examine images of Proxima 4's equatorial jungle spots and discover an **artificial structure** at each one's exact center.

The still orbiting *Kardashev* made geologic soundings that penetrated 200 feet below the surface in the area of the mysterious intakes. Early indications reveal enormous subterranean metallic constructs (some scientists are calling them machines) that appear to be designed by an intelligence not indigenous to Proxima 4. Although the exact function of the alien machines is undetermined, there is one theory that most Worlds scientists accept.

The builders of this alien world placed terra-forming engines at exact points around the equator of Proxima 4 yet left little evidence of their incredible handiwork.

Had Brooks not come upon one, the origins of the planet's ecosystem may have eluded scientists for decades. Though there are more unanswered questions than not, scientists now make educated guesses as to why the planet's evolution seems accelerated.

On Earth it would be as if all epochs were to exist simultaneously in a Darwinian jumble of intense competition. Perhaps the alien designers of this burgeoning world are in a hurry, operating on a scale of thousands of years rather than millions.

Some team members still harbor hope that Brooks eluded his pursuers. Others believe he may have fallen into the mouth of the great terra-forming engine. If so, is it possible that his DNA will, in some way, influence the evolution of Proxima 4's life-forms? Could Brooks have become part of the world he ventured to explore? Plans for a recovery mission are currently under way. By the time we reach Proxima 4, we may discover a far different world than we expect.

Conclusions

...he awoke to the subtle tingling at the base of her neck and rolled from her back to her side, drawing her knees up in a fetal position. She was well educated, and on some level felt embarrassed about her preference for this pose, as if understanding its prenatal origin should somehow strip t of its effect. The hell with it, lying this way made her feel *safe*. She waited for two more waves of tingles before she'd get out of bed, as was her habit.

Once she stood up, the tingling stopped; the implant reading her nner ear equilibrium. Outside her dome the jungle was quiet. This was her favorite time of the morning—the nocturnal animals were crawling, lying, or burrowing away from the day, and the diurnal animals had not et awakened. She thought of this time as the lull between shifts and magined the creatures passing each other as they punched an old-fash-oned time clock. The best part was that the primates were just stirring and were at their least skittish and most trusting. She'd been in the jun-gle for three months and was just starting to earn one group's trust. She oulled on her boots, grabbed her pack, and headed out. If she didn't get o their nesting ground in time she'd have to start building that trust all over again. If only she could put this much time into a relationship, she hought. *But if I put time into that, I wouldn't have time to put into this.* t was the old circular logic that always brought her back to the same olace. Maybe when she was done with the study of primate family groups she could have a family of her own. Until then she'd stick to her mantra: *Don't drag someone else into your silly obsession.* She punched the key-oad at the camp perimeter, deactivated the shock field, stepped across the hreshold, then reactivated it.

She walked through the dense underbrush without a sound. It wasn't that she was unusually stealthy; in fact, she'd always thought of herself as a bit of a klutz. The soles of her boots were equipped with sound-nullifying transmitters that emitted sound waves that were in ohased opposition to the sound waves her steps created. Any noise occur-ring in a 6-foot radius was suppressed almost completely. For safety rea-sons, the "bubble" of silence only operated three feet from the ground, so hat if the wearer needed to shout for help, their voice could be heard. She found that by squatting into the bubble, she could suppress any unwanted vocalizations, which came in handy for sneezes or the occa-sional off-color utterance due to a frequent brush with a spiny plant. She also carried a holographic blind, which enabled her to erect a 3- by 3-foot square box that concealed her body within an image of the sur-rounding foliage. It was an effective illusion that rendered her invisible out offered no protection from any animal that might stumble through it

More than once she found herself in a migratory route and had to pick up the device and hobble out of the path of an oblivious oncoming herd, all the while trying to stay concealed. If anyone had been there they would have seen her disembodied feet scampering away, silently, of course. Embarrassing moments like that only reinforced her desire to work alone.

The hum of early rising insects grew in the humid air, remind-ing her to pick up her pace. It wasn't far now, and she could smell the sweet odor of the deciduous tree where the primates nested. It was an enormous old-growth tree whose sugary bark was the main food staple of its residents. The bark also attracted insects and other creatures that added variety to the primate's diet. The tree was its own world, and the primates were at the top of the hierarchy, both literally and figuratively. Soon the mini-ecosystem would be a bustle of activity, and she didn't want to be late.

There had been a breakthrough yesterday. She had been sitting cross-legged on one of the huge tree roots that had been exposed by years of rainfall, its moss-covered surface a contrast to the coarse-textured bark on the trunk. She had taken that spot so as to be in plain sight of the group and had been there every day for about eight days. With each pass-ing day, the group seemed to occupy successively lower tiers of branch-es, going about their business but stopping for periods to study her. Yesterday a male threw down a small, mostly eaten carcass of some indis-tinguishable animal. She wasn't sure if the gesture was a threat, but she slowly picked up the scrap and pretended to eat it, trying not to react rudely to the smell of the meat. She was a guest after all and an uninvit-ed one at that. Soon, most of the group was participating in the behav-ior by pelting her with all manner of half-eaten morsels, and she polite-ly pretended to finish them. As suddenly as this outpouring of generosi-ty began, it ended. The group of 20 peered down at her, heads cocked with concern. For a moment she felt vulnerable, unsure of how to read the situation.

Suddenly, a young male broke ranks and cautiously crab-crawled his way down the massive tree trunk. The primate stopped a cou-ple of feet from the researcher and stared at her. She picked up a piece of bark and pretended to eat, hoping to reassure him. He watched her care-fully, and when she was finished, he reached out toward her. She placed the bark into his outstretched palms, his long fingers wrapping around it. He examined the bark carefully, running his fingers across the sticky uneaten side. In a blur he was up the tree and displaying the piece of bark to his family members, eliciting a chorus of chirps and grunts. The large

alpha male grabbed the bark, stripped it with his teeth, and hurled the remnant down hard at her, grazing her shoulder. Simultaneously, the group turned their backs to her and made no further eye contact.

They're insulted! They knew I was pretending to eat and now they're insulted!

The primates were smart enough to know when they were being patronized. The ability to feel insulted required a combination of intellect and, perhaps more significantly, *emotion*. That was more than she could say about most of the primates she had dated, let alone studied in the field. Now she just had to make amends for her ungracious behavior.

That night she ran tests on the tree bark and, upon determining that it was safe to eat, resolved to come back the next day to make amends. Again she returned to the base of the tree, this time ready to eat bark as her initiation into the group. The only problem was that the group was gone. Their bowl-shaped nests were empty, and the tree, which should have been awakening with the sounds of their early morning pat-ter, was silent. Had they migrated? This species wasn't migratory, as far as she knew. Did they deplete their food supply? This tree was so huge that it would take more than 20 primates to do that. *Oh, God. Did they leave because I hurt their feelings?* She had to work hard to shake off that feeling. It reminded her of when she was 11 and made the mistake of telling her Aunt Amy that she didn't care for her Thanksgiving yams. Before she knew it, she was receiving lectures from family members about manners and hurting poor Auntie Amy's feelings. Even after they forced an apology out of her, she still felt marginalized. Well into adulthood her relatives would make a show of not passing her Aunt Amy's yams at Thanksgiving. *What kid likes the taste of rum? And who wants to eat tree bark?*

She sat for several hours waiting for their return then eventual-ly headed back to camp. At the perimeter she touched the pad, crossed through, reactivated the shock field, and made her way toward the dome. Halfway up the path, she stepped on a wrapper from a ready-to-eat meal. It crinkled soundlessly under her foot as noises from around the bend caught her attention. Sidestepping the path, she cautiously made her way through the brush toward her dome.

Most of the primates were busy with her food. They had piled it in front of the dome and were systematically unwrapping the packages. Not all the food met their liking, but the desserts seemed to appeal to their sweet tooth. One primate had found her pocketknife and was busy scrap-ing the bark off a nearby tree. Others had laid some of her clothes on the ground and were carefully examining them, rubbing the fabric between...

...her thumbs and forefingers. She was struck by the calm order of the scene. This was not a bunch of wild animals running amok with civilized man's fineries. This scene had the air of shoppers at a yard sale, inspecting and evaluating not just the goods but the seller as well. She had the feeling she was being judged.

Got to stay hidden, she thought. This is good stuff. She reached down slowly for her pack that held her holographic blind. She groped through the brush, never taking her eyes off the scene in front of her. Unable to locate the pack by feel, she glanced down. There in front of her was the young male primate, clutching her pack. He bared his teeth and flapped his jaw without making a sound. As soon as he stepped out of the sound bubble, his staccato jabbering drew the attention of the entire group.

All activity ceased. The primates stared at her blankly. Here it was again, that moment in animal behavior she'd never been able to read. Was it a matter-of-fact acknowledgement of her presence before going about their business or the prelude to an attack? If she ran, she had to make it to the keypad and deactivate the shock field then get to the other side and reactivate it, trapping the primates in. She played the scenario in her mind and quickly realized there was no way to outrun them. Two legs versus four rarely win in a race.

The tension of the situation made the stare-down seem to stretch into subjective time, which made it all the more abrupt when the primates broke their stare and began methodically putting things back where they found them. The last thing she expected was that they'd tidy up their mess, and she exhaled a laugh that was more a sigh of relief. Half-eaten rations were tucked back into foil wrappers, clothes were folded (sort of), and the pocketknife was slipped back into its leather sheath. *Unbelievable. No other primate in the wild has shown this kind of organizational thinking,* she thought. They were almost as interested in the way her belongings were arranged as the objects themselves. After a few minutes of straightening up, they filed past her quietly with barely a glance her way, and headed down the path.

She poked her head into the dome, her mind still processing what she had just seen. The space was back in order; not in perfect order but generally things were put back where they belonged. They just walked in, explored her world as she had been exploring theirs, and then walked out. *Oh, my God! The shock field! They're headed right for it!* The field had been preset by the university with enough of a jolt to deter larger animals. She had lobbied to be given the authority to vary the setting depending on the local wildlife, but she had been overridden because of...

...insurance concerns. She set off running down the path, angry with herself for not insisting. A jolt that could injure a large animal could be fatal to a smaller one, and she picked up the pace as she pictured some of the group's young. *Wait a minute...I had to deactivate the field to get in. How did they manage to get over it in the first place?* Perhaps there was an overhanging branch that they had dropped from. Could they have dug underneath it? How did they even know it was there, given that it was invisible? She felt uneasy as she wondered exactly how intelligent these creatures were. She was out of breath when she got to the keypad, and what she saw didn't make her feel any better.

The entire group was walking calmly away on the other side of the shock field. The large alpha male was at the rear, carrying a meter-long stick and walking on two legs. He turned back and glanced over his shoulder at her as she stopped at the keypad. It was active. *He knows the code!* The old primate turned and waddled down the path, occasionally swinging his stick at leaves normally out of his reach.

The next morning she awoke before the implant tingled. She hustled to get to the tree, grabbing her pack and throwing it over her shoulder. It didn't have the same heft as usual, and she rummaged through it as she walked. The holographic blind was missing. She pictured the jabbering young male and decided to name him *Brat*. As always she was hit with the sweet smell of the tree's bark and knew she was close. As she drew nearer she was able to make out the great tree's shape through the early morning mist. First the overall silhouette, which reminded her of an enormous cauliflower, and then the jagged lines of the pale branches like horizontal lightening bolts. She approached and entered one of the corridors formed by the roots that radiated from the tree trunk. Looking straight up, she saw that every nest was gone. Ragged vegetation hung from spots where each nest had been.

Her heart pounded as she jogged around the base of the tree, looking up for any sign of the group. Suddenly, her foot was caught on something protruding from the ground, and she fell hard onto her side, knocking the wind out of her. *Tree root, you klutz!* She looked back, expecting to see the offending root, and instead saw Brat's disembodied head floating two feet off the ground and jabbering silently at her. She drew her feet toward her, and the sound of his tirade abruptly cut through the air. He stepped out of the holographic blind becoming wholly visible for a moment, and then withdrew, disappearing again.

She staggered to her feet and leaned against the tree. A scraping sound drew her attention to another primate, who was using her pocketknife to cut the bark off the tree. He glanced blankly at her and...

...went about his task. Several females appeared, gathered piles of loose bark and carried them around the tree and out of her view. She followed giving the primate with the knife a wide berth.

There were the nests. Arranged in a circle on the ground, the bowl-shaped nests had been turned upside down and now resembled...domes. Primates crawled in and out through openings (probably cut with the pocketknife) in the side of each shelter, distributing pieces of bark. She sat down on a root, taking it all in. From the center dome, the alpha male popped his head out, looked at her, and retreated momentarily. He reappeared, cupping something in his hands and walking toward her on two legs. He extended his arms and opened his hands, showing her a wad of green leaves. She began to reach for it but hesitated when she noticed that some members of the group were approaching with interest. The male gestured and she delicately buried her fingers into the cluster of leaves, feeling an object wrapped within it. She recognized the smooth, cold lines as something of hers that she didn't even know they had taken from her camp. Now they were giving it back, perhaps sensing that it was of great meaning to her. She lifted the object, the leaves falling to the ground, and pulled out a music box with a china ballet dancer atop it, arms outstretched. *4.2 light years without a scratch. Thank God, it's not broken.* The entire group was now surrounding her. The alpha male reached out his hand and made a twisting gesture. She wound the key and set the music box on her flattened palm. The ballet dancer began to turn. She held it up and out of the sound bubble, and the halting notes of "Beautiful Dreamer" wafted over the group, quieting them.

The primates sat down slowly, almost in unison, entranced by the music. Margaret knew that the luminous glow pulsating through their soft, fleshy throats was a sign of contentment. There were no primates on Proxima 4 when her father came here some 20 years ago, yet they were already taking their first steps toward civilization. How much they would advance in the next 20 years was anyone's guess, but she knew she'd be here to document their evolution. Soon she'd be able to run tests to determine their origins and to find out whether the kinship she felt was merely academic curiosity or some genetic connection. As she looked into the eyes of the alpha male, she felt her father looking back at her from across light years.

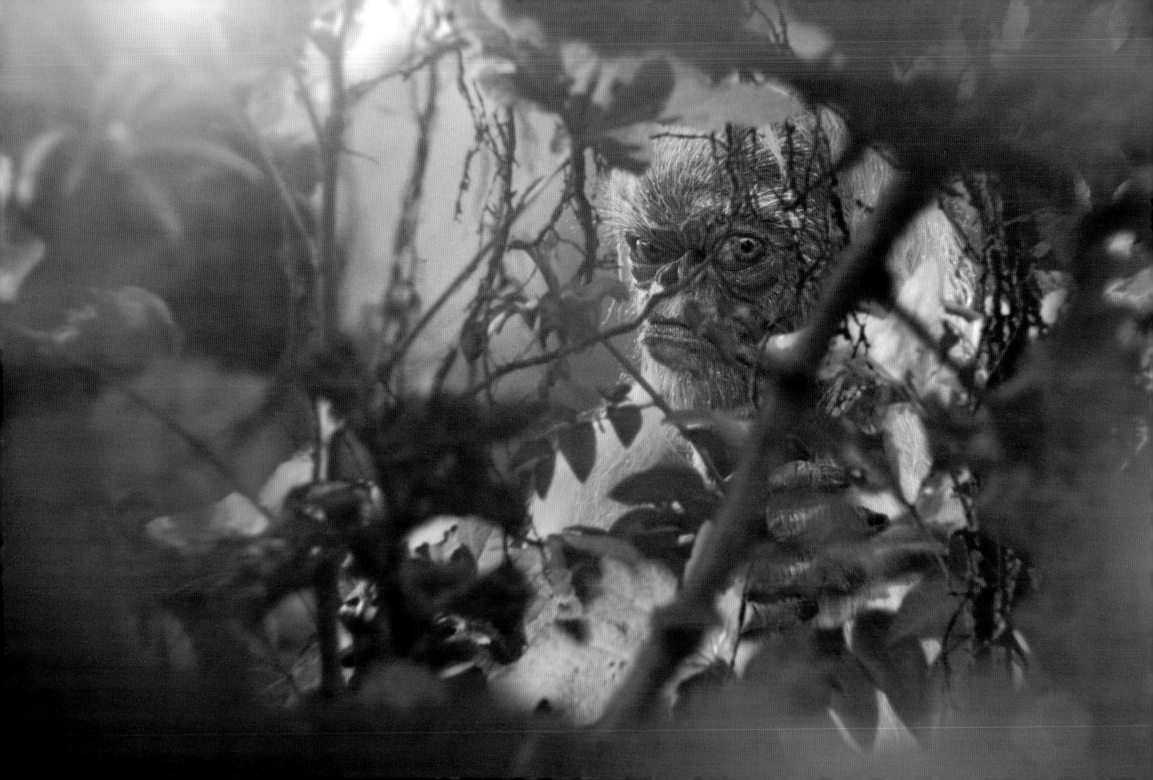

WORLDS TEAM

Steve Koch – *Photography, Miniatures, Digital Art, Sculpture*

Kevin McTurk – *Miniatures, Photography, Sculpture*

Chris Ayers – *Miniatures, Digital Art, Sculpture*

Jordu Schell – *Sculpture, Creature Design*

Dave Penikas – *3-D Digital Art*

Eric Hayden - *Miniatures, Digital Art*

Bill Church – *3-D Digital Art*

Seth Hays - *Miniatures*

Jeff Buccacio - *Sculpture*

Don Lanning - *Sculpture*

Mario Torres - *Sculpture*

Brad Cronce - *Sculpture*

Tim Martin - *Sculpture*

Matt Killen - *Sculpture*

Mike Manzel - *Sculpture*

Mike Larrabee - *Painting*

Pete Farrell - *Painting*

Jim Hogue – *Painting*

Sean Kennedy – *Compositing, Digital Art*

Takahiro Mizuno – *Painting*

Thasja Hoffmann - *Miniatures*

Yuri Everson - *Miniatures*

Brandon Lawless – *Sculpture*

Steve Kuzela - *Miniatures*

Lou Kiss – *Digital Compositing*

Corey Yaktus - *Compositing*

Charles White – *Digital Art*

Craig Ashby – *Photography*

Dr. Richard B. Buck – *Science Advisor*

* WORLDS author Alec Gillis can be contacted at worldsadi@aol.com

* WORLDS artist Steve Koch can be contacted at skworlds@earthlink.net

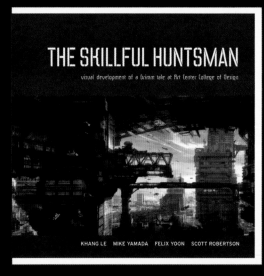